Drawing
MANDALAS

Drawing
MANDALAS

How to create beautiful, intricate patterns

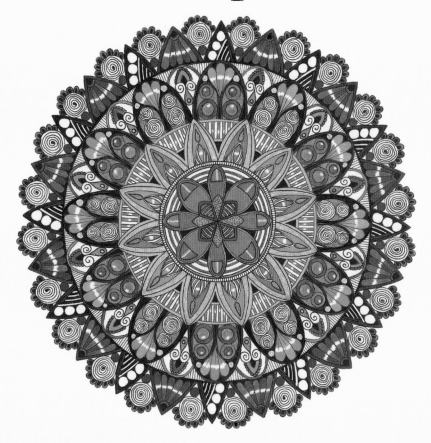

HANNAH GEDDES

SIRIUS

Introduction

Welcome to the wonderful world of mandalas.

Learning to draw mandalas is easy and doesn't require any previous experience which means they are suitable for all ages and abilities. They might look complex and daunting for a novice to draw, but If you are able to draw a straight line, a circle, a square, and a triangle then you will be able to draw mandalas. This book is suitable for beginners, as well as more advanced readers, and those who want to learn to slow down, relax, and learn a new hobby.

This book has been written as a starting point for drawing mandalas, and offers guidance to get started on your journey into creating your own. You don't need a vast array of expensive tools, just a desire to learn, and time to practice, practice, practice.

We all know how anxiety and stress can damage both our mental and physical well-being. We are advised to take time out for ourselves, try new things and generally look after ourselves better. Creating mandalas can help us to achieve this and find a good balance between work and play.

Drawing mandalas isn't just about creating pretty pictures but more about the process, slowing down, focusing, self-reflection, and calming the mind. They are fun, freeing, and a great way to unwind, and there are limitless possibilities to create beautiful pieces of art and enjoy the moment. Once you have learnt the basics, the possibilities for your mandala arts are endless and will enable you to explore and put your own artistic stamp on your pieces. You can start with simple designs and move on to more intricate patterns as your confidence grows.

In this book I'll show you how to create mandalas step-by-step, the materials needed, the design process, some mandala-related projects and inspiration. We will cover terminology, ideas to get started, tips and techniques, benefits, patterns, practice, inspiration, and will hear from other artists who draw mandalas. The more you draw the more skilled you will become, and by the time you finish the book you will have all the information you need to put pen to paper.

Find yourself somewhen quiet, get comfortable, and let's get started and have some fun!

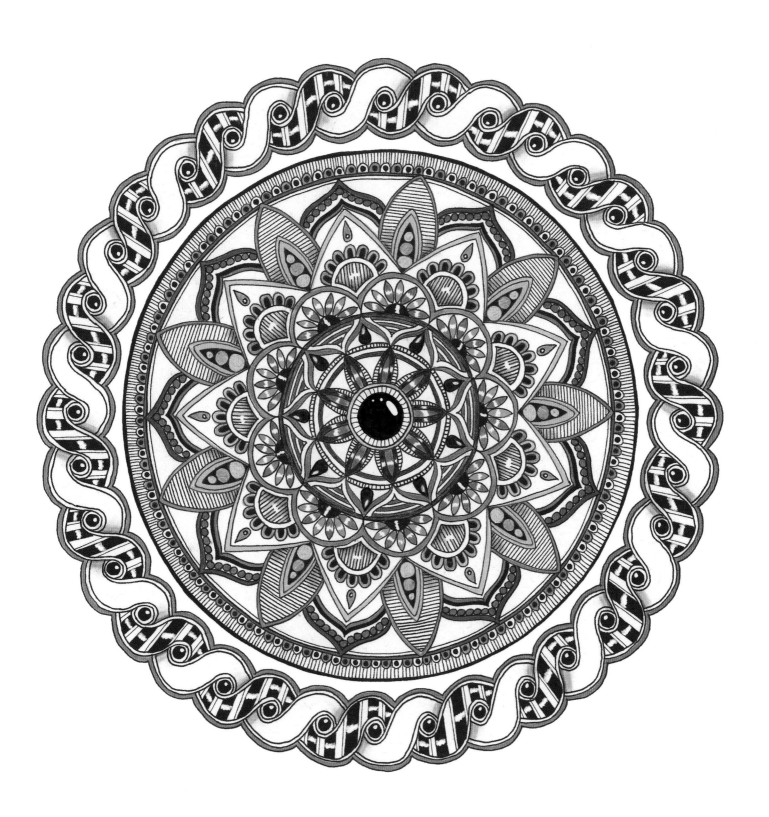

Chapter 1
What is a mandala?

Mandalas have different symbolic meanings in different cultures and religions but are fundamentally diagrams or drawings which are normally circular. They are made from geometric and abstract designs which are symbolic and have roots in Buddhist, Tibetan and Hindu cultures. Mandalas are used as part of a ritual to create a sacred space on a spiritual journey in which they represent the universe, unity, and wholeness.

Mandalas are found all over the world. In Asian religious practices creating mandalas can be used as a tool on the path to enlightenment, mindfulness, meditation, contemplation and concentration. They can be made on a variety of materials including scrolls, paper, walls, cloth, stone and on floors. They can be simple designs or very complex and can be drawn while meditating on your chosen subject. Mandalas can be found across most cultures including Native American, Aztec, Arabic and in Christianity.

The word 'mandala' is an ancient Sanskrit word that can be translated to mean "circle" or "completion." It has been seen as a symbolic representation of the harmony of the universe, balance and infinity. The word "manda" meaning essence or core and "la" meaning container, when combined means a "container of essence."

Mandalas start from a center point and build up, radiating outwards in concentric circles. As the circle has no beginning and no end it can represent that everything is endless and connected. Patterns are made using repetitive shapes, symbols and motifs. Once you know how to create the basic steps you can explore designing with new base substructures, designs, shapes, patterns, elements, and colors.

You can see mandalas across the world in temples, churches, cathedrals, stained glass windows, architecture, fractals in nature, flowers, snowflakes, and shells.

Traditional mandalas created by monks are painted on flat surfaces. They consist of four gates that form a square surrounding an inner circle containing a deity known as a yantra.

More modern mandalas have become pieces of art which are hand drawn on paper or card using pens and pencils, or digitally created and replicated for people to color for pleasure, or as a tool to aid in art therapy. Commercially, mandalas have become very popular for use in decoration, fabrics or home decor and I've seen them on everything from bedding to tissue boxes to business logos to fabrics, to

You can create mandalas out of anything. While on a walk start collecting objects such as flowers, leaves, shells, pebbles, and acorns to create a colorful natural mandala.

ceramics. These last vary depending on which culture they are from; the designs on ceramic tiles are beautiful, bold and vibrant and I can find myself lost when looking at them.

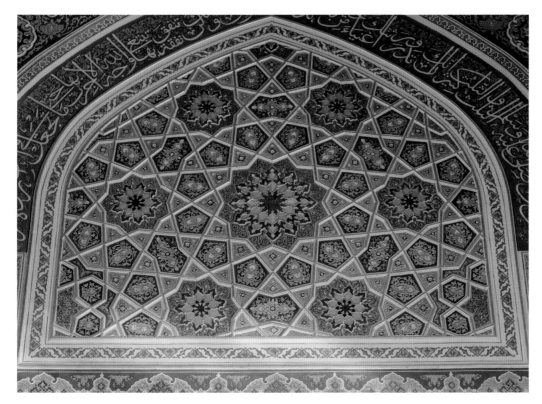

Tiles on the ceiling of a mosque in Uzbekistan have a mandala at their center.

Mandalas in religion and culture

It is thought that mandalas originated in Asia and were first created between the 1st century BCE and 4th century CE. They have been used since in eastern cultures and religions as a form of meditation, prayer, healing, or as part of a sacred spiritual journey. They are also used as a therapeutic tool to focus on the present as an aid to relaxation.

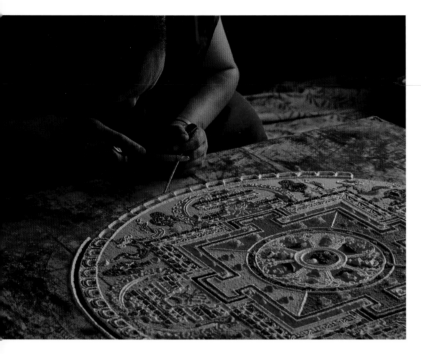

Buddhism

Buddhist monks would study philosopical, symbolic and artistic teachings for around three years before being able to start creating mandals. Traditionally Buddhist monks create a mandala as part of a ritual that begins with the blessing of the site. They chant mantras to invite their deities into this sacred space and draw a precisely rendered template in chalk on the ground or on a flat board incorporating intricate geometric, organic shapes and designs. Using either crushed stone or colored sand the monks distribute the sand using metal funnels called *chak-pur*. They can spend days or weeks creating elaborate and colorful designs.

A Buddhist monk making a colored sand mandala.

A sand mandala is destroyed during a special ceremony.

During the creation of the mandala the monks meditate and seek enlightenment on their spiritual journey. Once the mandala is completed the monks pray over it and then destroy it by either sweeping or blowing the sand away and collecting the remaining sand into an urn or jar. The sand is released into a stream to allow the blessings to be transferred to local communities. The destruction of the mandala signifies that nothing is permanent: the world is constantly in a state of flux, is changing all the time, and is temporary.

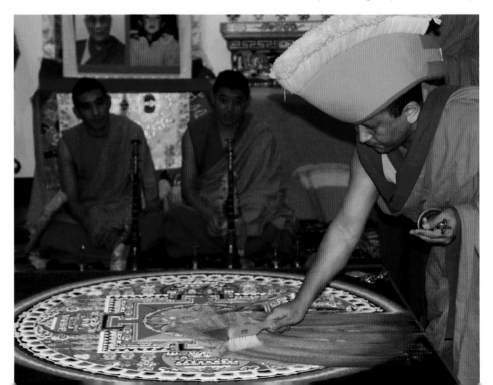

Thangkas

Thangkas are Tibetan pieces of art painted onto flat surfaces such as walls, fabric, or scrolls and are used to depict and pass on the teachings of the Buddha. They might show the wheel of life, Buddhist deities, historical events, and mandalas. Monks and lamas could carry the thangkas rolled up into silk or cotton scrolls to offer blessings, for sharing Buddhist teachings, and for meditation while traveling.

Those who drew thangkas took many years to study the method. The creation process is important, from preparing the canvas to painting the exact proportions, to using the right materials to achieve the correct colors. Deities were painted using geometric shapes laid out in very intricate and precise symbolic forms shown in the scriptures. Crystals, minerals, or plant substances were ground into a fine powder mixed with water and animal glue to make a paint, and the thangka could take weeks, months, or even years to complete.

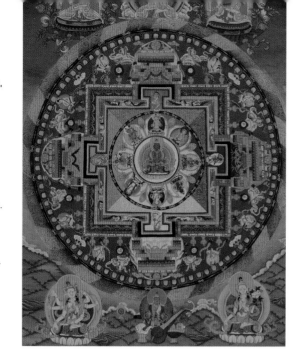

An ancient thangka on the wall of the Thikse monastery in Ladakh, northern India.

Mandalas today

Drawing geometric mandalas, coloring in and dot mandalas have become popular forms of art over the last few years and can be used to aid those suffering from stress and anxiety. They can be drawn on a variety of surfaces using pens, pencils, paints, inks, and other media. I have even seen artists drawing huge mandalas on the beach using a stick and rope, and had the pleasure of joining an expert on the beach while I was in Wales.

There are many reasons for creating mandalas, but a general rule is that by making them pleasing to the eye, you will focus and stop negative thoughts getting through. Should an irritating or distracting thought enter the mind, you can refocus back to the mandala to get rid of the unwanted thoughts. I've found that all sorts of people can benefit from just sitting down and drawing for 20–30 minutes: stressed out adults, those studying for exams, children, and teachers.

A large-scale mandala drawn on flat, fine sand near the sea.

Dot mandalas are created using bright paints and can be painted on wood, stones, ceramics and all sorts of substrates. They also start with a dot at the center which is then surrounded with lots more dots of varying sizes and colors, creating geometric and organic shapes.

A selection of brightly colored dot mandalas.

Other influences and inspirations

Inspiration for mandalas can be found everywhere. I love the colors used in Rangoli art and the lacy, floral designs of Mehndi patterns. The structure found in architecture, sacred geometry and Celtic symbols and the lines and composition in Arabic arts. Once you start looking you will see mandalas and patterns everywhere. I've included a few that I enjoy but there are many more – so explore and find your inspiration.

Sacred geometry is based on a study of the spiritual meaning of mathematical shapes, proportions, forms, and numbers. These examples can be found in religious buildings including in churches, temples, and mosques. In nature, for example, the nautilus spiral shell, flower petals, and pine cones. Fractal geometry can be found in snowflakes, DNA, crystals, and galaxies. I find them really enjoyable and meditative to draw using a compass, accuracy, and some concentration.

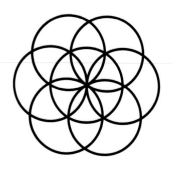

The seed of life

Torus

The flower of life

Carl Jung

Swiss psychoanalyst, Carl Jung (1875–1961) used mandalas as part of his practice and believed that they were a representation of the unconscious self. He drew his first mandala in 1916 and continued to draw circular drawings on a daily basis. He did not realize their symbolic meaning until he studied eastern religions many years later. He used drawing mandalas as a therapeutic tool and promoted their use in art therapy to diagnose emotional disorders in his patients.

Jung believed that the process of creating a mandala was just as important as the finished piece and that each of the three layers, the inner, the outer, and the secret have different meanings. The inner layer creates a map to guide the mind to enlightenment. The outer layer represents the divine form of the universe, and the secret layer is just between the creator and the mandala; together they represent an overall balance of clarity for the mind and body.

Jungian mandala

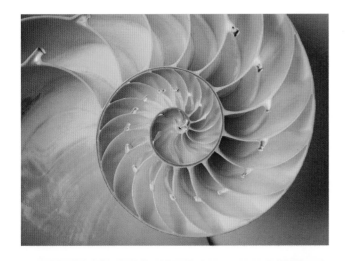

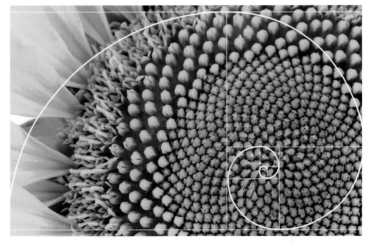

The golden ratio shown via a nautilus shell spiral and the spiral that can be found in the center of a sunflower.

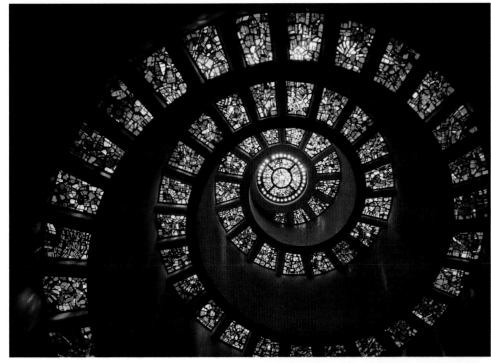

A stained-glass window in a church in Dallas, Texas beautifully recreates the mathematical Fibonacci sequence.

Aztec and Mayan mandalas

It is thought that the Aztec and Mayan cultures of south and central America used mandalas made from stone for calendars as methods of time keeping. These sun stones were made using symbols, numbers and motifs, each with their own meanings.

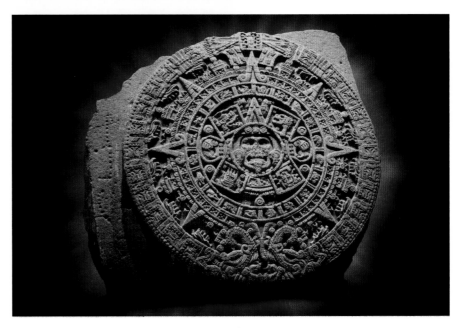

Colored sand at a market in India, used to create rangoli.

A series of highly detailed mandala patterns made using fine white rice flour in Chennai in the south Indian state of Tamil Nadu.

Rangoli

Rangoli is a style of Indian folk art created on the floor using different colors of very fine powder, sand, grains, rice, or petals. This method is used to make pieces of art at the entrance to the home to welcome guests, for good luck, prosperity, festivals, celebrations, and other special occasions.

They can be made up of geometric and organic floral patterns as well as those found in nature such as peacocks, fish, the sun, moon, and deities. The designs can be simple or very complex and use patterns, motifs, and symbols, the more colorful the better.

In southern India they are known as *kolam* or *muggu* and can be created using rice flour, chalk or stone powder. These are often more symmetrical in style as they are mostly made up of strokes that run around a dot.

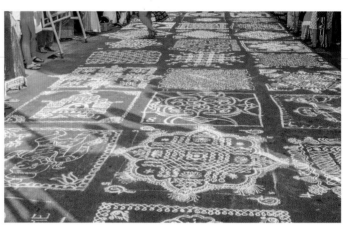

Islamic art

Islamic mandalas can be used to reflect on life and are made predominantly using circles, stars, and squares that can be woven and overlapped to create very intricate patterns. These designs can be found in mosques, architecture, stained glass, and ceramics. I enjoy looking at the beautiful and colorful ceramic tiles and the amazing domes in temples and mosques.

The exquisitely detailed ceiling of the Lotfollah Sheikh Mosque in Isfahan in central Iran.

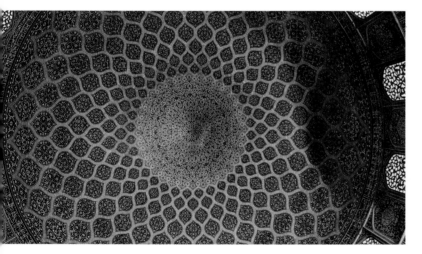

Mehndi

Mehndi is a form temporary body art, drawn on the skin using henna dye. It is made from dried henna leaves crushed into a powder and mixed with other natural ingredients to form a paste which is then applied to the skin. The ingredients mixed with the henna will determine the final color and the designs range from white to orange, to light and dark brown. Mehndi designs are used during Hindu, Muslim and Sikh wedding ceremonies and Indian festivals when the hands, feet, arms, and legs are decorated.

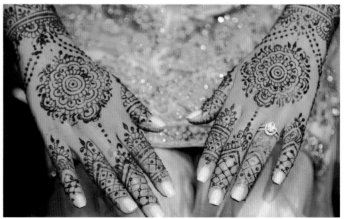

A bride shows off the detailed henna decorations that have been drawn onto the backs of her hands.

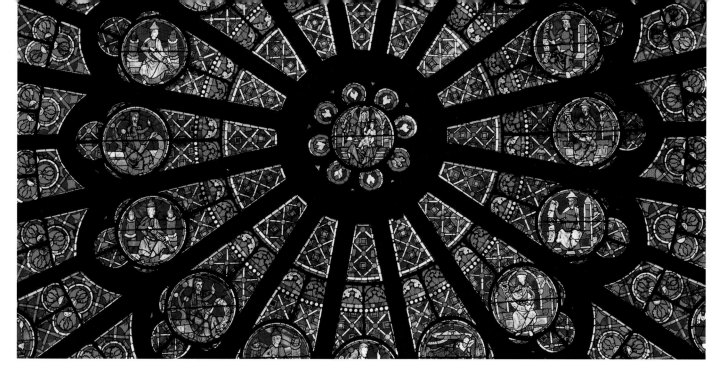

Notre Dame cathedral in Chartres, France is a miracle of medieval architecture and is an amazing place for inspiration: from the stained-glass windows to the labyrinths on the floor, it's a great place to look for patterns.

Christian architecture

Mandalas can be found throughout Christianity, decorating the floors and ceilings in cathedrals, churches, in stained glass rose windows, and in Celtic spirals, crosses, and knots. Celtic knots and spirals can look complicated to draw but once learned can provide a very relaxing way to spend some time. I like to draw a knot either at the center of the mandala or as the border, and find the weaving part of the drawing process very mediative.

Right: A compass rose could be the starting point for a mandala.

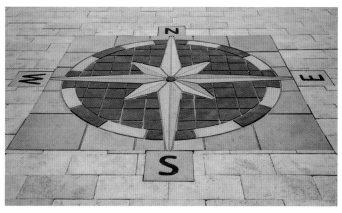

An ancient spiral stone carving at the entrance to a Celtic passage tomb in Ireland.

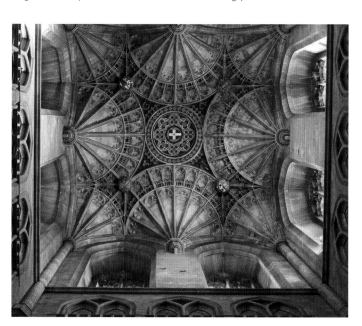

The design at the center of the nave ceiling at Canterbury cathedral is surrounded by exquisite fan vaulting.

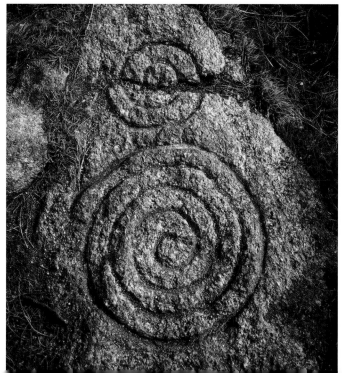

The benefits of drawing mandalas

Drawing mandalas is magical and fun, I've listed a few reasons to pick up a pen and paper and get started.

 As you don't need any special tools/equipment and no previous experience is required, people of all ages can enjoy creating mandalas anytime anywhere.

 Mandala arts can help you to unwind, free up your mind and assist in unleashing your creative side.

 I find that when drawing simple repeating designs, it helps me to slow down, relax, focus, and concentrate.

 Mandalas have been found to aid sleep, ease depression, and reduce anxiety.

 When drawing mandalas I find peace, a level of calmness, balance, and harmony.

 Drawing intuitively with repetitive patterns can encourage the freedom for a mindful and meditative experience.

 If I'm struggling to make an important decision and my mind seems to be resisting then I will sit myself down and start drawing; often this will help to clear whatever was causing the blockage and enable me to resolve the issue.

 When I'm drawing and designing mandalas or playing with patterns it lifts my mood and makes me feel happy.

 Creating mandalas can be used as a form of art therapy and help people suffering from various illnesses. Both adults and children can benefit from sitting down for 30 minutes and drawing a mandala.

 Some students have told me that they have drawn mandalas for stress relief, pain management, and to help reduce their anxiety.

 It's an activity that can be done in a group with parents and children, or in schools to help soothe the mind.

 Most of all it's easy, fun and simple to creating a piece of artwork that looks amazing and can be framed and hung on the wall.

Terminology

Annulus The space in between two concentric circles.

Arc A portion of the circumference of a circle.

Border The pattern around the outer edge of the largest circle.

Buddhism A religion founded in India by the Buddha more than 2500 years ago.

Center dot A fixed dot in the center of a circle, used as the starting point when creating mandalas. It symbolizes the primary deity used in the mandala.

Celtic knot A knot style design with no beginning or end which symbolizes infinity

Circumference The distance around the outer edge of each circle.

Concentric circles Circles that get larger in diameter starting from a center point.

Diameter The distance across the circle from edge to edge via the middle of the circle.

Degree The measurements of the angles inside a circle.

Elements The shapes that make up patterns. They are made from both geometric and organic shapes.

Fillers Patterns used to fill the sections inside the shapes drawn in a mandala

Geometric shape Mathematical shapes consisting of straight lines, angles, and points.

Hinduism Religion founded in India more than 4000 years ago.

Mandala Diagram representing the universe, normally arranged around a center point.

Mindfulness Type of meditation focusing on the breath and being in the moment.

Motif A single element of a pattern which is then repeated.

Meditation A technique focusing on the self, perspective, and emptying the mind.

Negative space Empty space around the focus points of patterns or design.

Pattern A design made up of repetitive shapes, lines, symbols, and forms.

Organic pattern Found in nature and comprising flowing forms and lines that are irregular and imperfect.

Quadrant An equal division of a circle into four parts.

Radial balance The symmetrical balance of patterns that start in the center and radiate outwards.

Radial symmetry Using the same patterns arranged around the center point.

Radius The distance from the center point to the edge of the circle; half the diameter.

Rotational symmetry When rotating your mandala, the patterns look the same from each direction or angle.

Sacred geometry Geometric designs and symbols used in art to symbolize the universe.

Segment A dividing line to separate different areas to form a pie-shaped wedge.

Semi-circle Half of the circle when divided into two equal parts.

Substrate The base material or surface on which the mandala is created.

Substructure A basic mandala guideline structure or grid which is normally drawn in pencil and later erased.

Symmetry The balance of patterns based around the center point.

Template A base design/grid drawn in pencil used as guidelines for a layout to create a basic mandala.

Wedge A pie-shaped segment.

Getting started

When drawing mandalas the process is just as important as the end result and as you don't need many tools, it's quick and easy to get started. Some people prefer to find somewhere quiet to sit and draw, while others like to have music on in the background. Find what suits you, gather your materials and let's begin.

Substrates

You can use a wide range of different surfaces for drawing mandalas. This selection includes both lightweight papers and more substantial cards.

1. Gray card
2. Black card
3. White card
4. Tan card
5. Off white cartridge paper
6. White dotty paper
7. Hand made watercolor squares
8. Round card coaster
9. Round wooden coaster

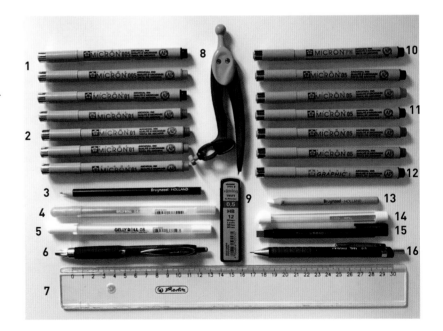

Drawing tools

While a biro is fine at first, I soon found I wanted more precise tools. I've shown some of the ones I prefer, that give me the best finish for my artwork..

1. Fine liner pen 005 nib pens
2. Fine liner 01 nib pens in various colors
3. Black pencil
4. Metallic gold pen
5. White 08 nib pen
6. 07 black nib pen
7. 30 cm clear plastic ruler
8. Compass
9. 05 replacement mechanical pencil leads
10. PN black pen
11. Fine liner 05 nib pens in various colors
12. 1 nib black pen
13. White pencil
14. Tip eraser refills
15. Refillable eraser
16. Mechanical pencil 05 nib

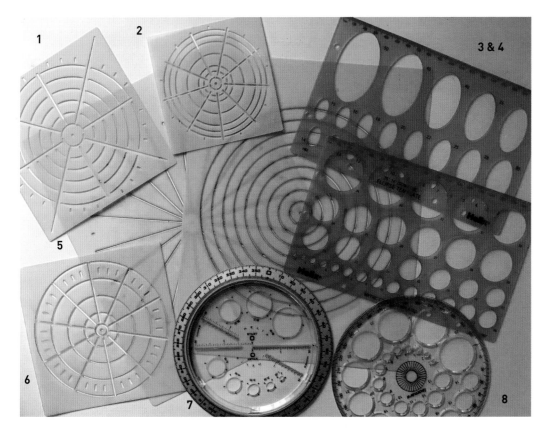

Stencils

A compass and pencil will suffice, but using stencils can offer more precision and be a great time-saving tool. I've listed a few that I use on a regular basis.

1. 5" mandala-making stencil
2. 5" mandala-making stencil
3. 4" mandala-making stencils
4. A4 two-part mandala-making stencils
5. Angle and circle maker
6. Protractor
7. Circles and ellipses template
8. Circles and ellipses template

Coloring tools

Some people choose to color their mandalas while others prefer to leave them in black and white. The surface you are using will determine the coloring materials you need. I've shown a few of my favourites.

1. Colored pencils
2. Colored pencils
3. Colored pens
4. Metallic colored pens
5. Pocket color wheel
6. Watercolor brush
7. Brush pens
8. Dual tip pens

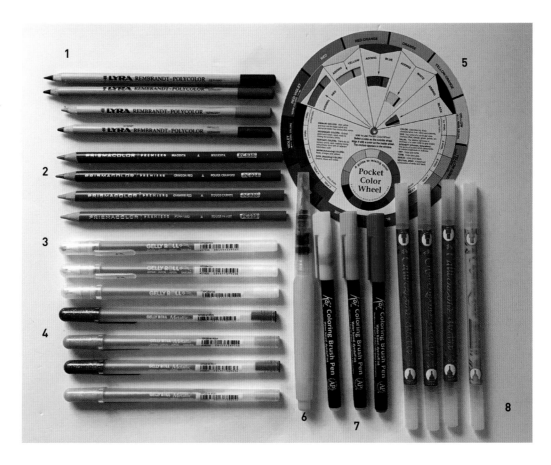

10 easy steps to get started

Follow these 10 simple steps to draw a mandala.

1. Sit in a comfortable chair and breathe.

2. Choose the paper, card, or other material to draw on, measure and cut it to your chosen size.

3. Using a pencil and ruler find and mark the center of the page (as shown on page 21).

4. From the center point draw concentric circles in varying sizes using a stencil or compass.

5. Draw a straight vertical line through the center dot from the top to the bottom then repeat, drawing a horizontal line through the center from left to right, finishing each line at the inner edge of the largest circle.

6. Using a protractor, compass, or stencil, lightly mark out degrees in pencil equally spaced apart. Using a ruler and pencil, lightly join these degree marks to the center dot to subdivide each section (see page 21).

7. Switch to your preferred pen and starting from the center point, add patterns in each section repeating this pattern around inside the same band.

8. Continue to choose and add repeating patterns, symbols, and motifs around each band introducing a new pattern for each layer.

9. Choose a suitable border style pattern to fill in the outer border of your mandala.

10. Your mandala is now complete. You can leave it as it is or add shading and or color. I prefer to scan and copy, then I can print and add color and shading on the printed version so I still retain an original that I can mat and layer to put in a picture frame.

Finding the center

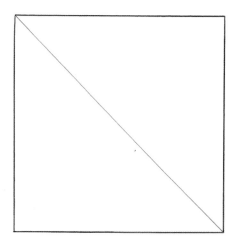

1. Draw a straight line from the top left corner to the bottom right corner

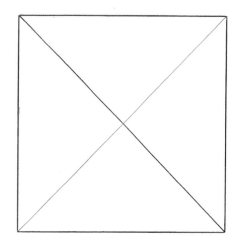

2. Draw a straight line from the top right corner to the bottom left corner

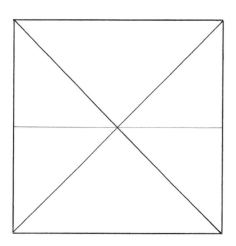

3. Starting halfway down the page draw a straight horizontal line from the middle of the page going through the center of the previously drawn diagonal lines.

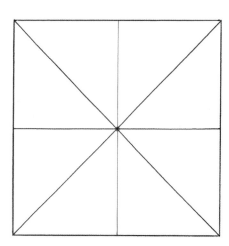

4. Starting halfway across the top of the page draw a straight vertical line down the middle of the page through the center of the previously drawn lines.

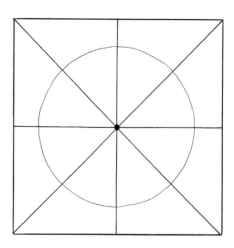

5. Using pencil with a compass or stencil draw a circle starting from the center point.

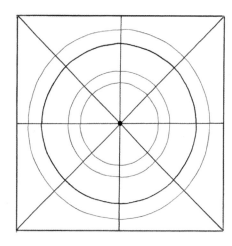

6. Continue to draw different sized circles starting from the center point.

Using a protractor to measure degrees

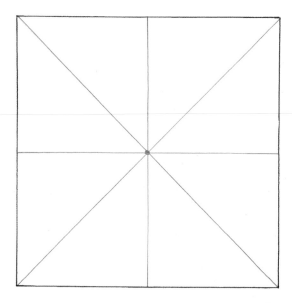

1. Using a pencil and ruler find the center point (using the instructions from page 21)

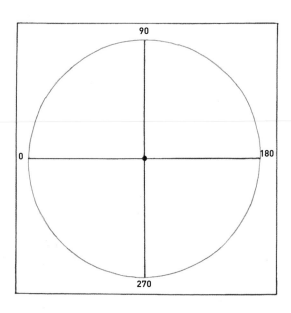

2. From the center point draw a circle: in the example I've chosen a circle with a 4 cm diameter. Use the horizontal and vertical lines drawn in the previous step from the center point.

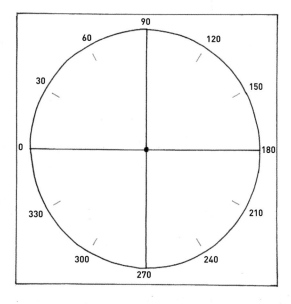

3. Place the protractor along the horizontal line and marry up the vertical lines with the center point. Using a pencil measure out your chosen degrees and make a mark. The example shows marks 30 degrees apart.

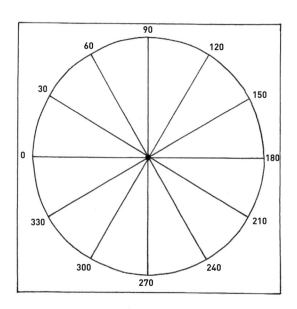

4. Using your ruler join draw straight lines from the center point to the edge of the circle.

Measuring out segments

This set of diagrams shows how to measure out degrees using a protractor.

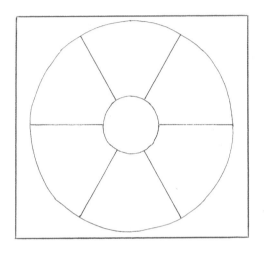

1. Six sections of 60 degrees at 60, 120, 180, 240, 300 and 360

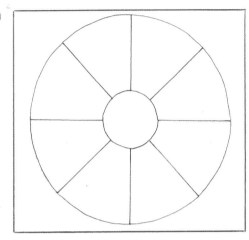

2. Eight sections of 45 degrees at 45, 90, 135, 180, 225, 270, 315 and 360

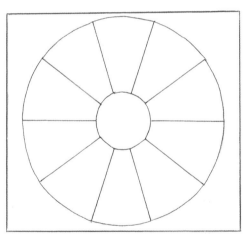

3. Ten sections 36 degrees at 36, 72, 108, 144, 180, 216, 252, 288, 324 and 360

4. Twelve sections 30 degrees at 30, 60, 90, 120, 150, 180, 210, 240, 270, 300, 330 and 360

5. Eighteen sections of 20 degrees at 20, 40, 60, 80, 100, 120, 140, 160, 180, 200, 220, 240, 260, 280, 300, 320, 340 and 360

6. Twenty sections of 18 degrees at 18, 36, 54, 72, 90, 108, 126, 144, 162, 180, 198, 216, 234, 252, 270, 288, 306, 324, 342 and 360

Parts of a circle

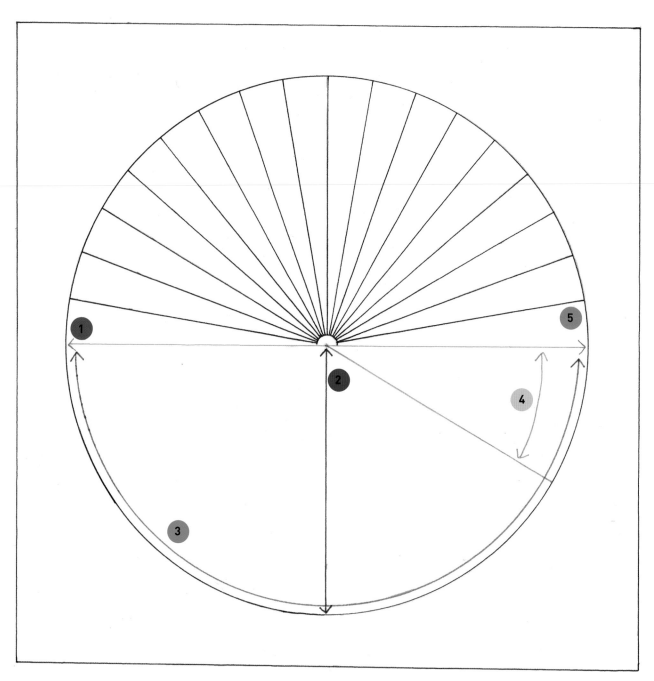

1. Diameter

2. Radius

3. Semi-circle

4. Segment/wedge

5. Degree points – here I have chosen to place them at 10 degrees

TOP TIP

When drawing pencil lines use a light hand so they can be erased easily when drawn over in pen.

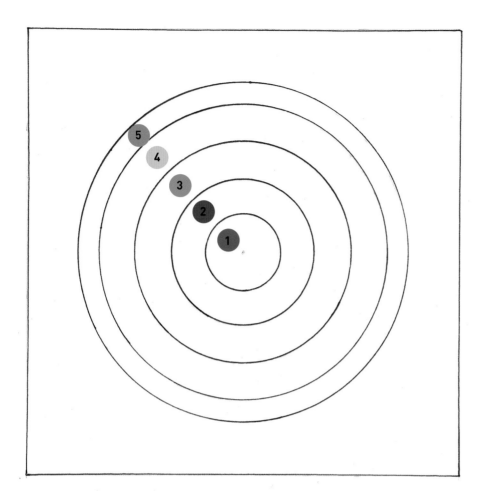

Labels for circles

1. Center circle
2. Inner band
3. Middle hand
4. Outer band
5. Border

1. Center point
2. Circumference
3. Segment or wedge
4. Sub segment or sub wedge
5. Annulus

Anything is possible

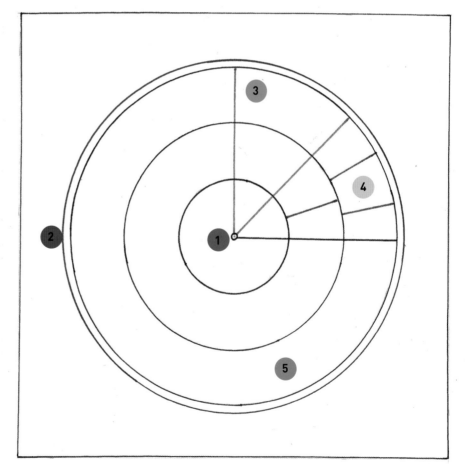

Two more ways to create a mandala base

Using two-part A4 mandala stencils

1. Gather your materials: card, pencil, pen, two-part A4 mandala stencil (see pages 18–19)

2. Find the center of the page using the method shown on page 21 and with a pencil make a mark at the center point.

3. Using the circle part of the mandala stencil, place the center hole over the pencil marking the center on your page and use a pencil to draw the concentric circles.

4. Switch to use the second part of the mandala stencil with the lines cut out. Place the center dot on top of the center dot marked in pencil on your card and use a pencil to draw the lines. Your base mandala grid is now ready for you to add your chosen patterns.

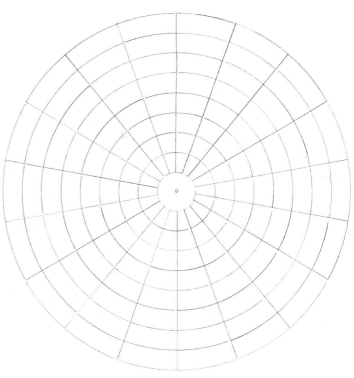

Pros

• You can quickly draw a pencil base substructure, which saves time and effort and gives you more time to enjoy drawing your mandala.

• All the decisions on the depth of concentric circles and degrees are already measured out so there's no need for a compass, protractor and ruler.

• Using the stencil doesn't leave a hole in the center of your paper or card as happens when using a compass.

• The stencil is long lasting and reusable.

• Allows more time for creativity and productivity

Cons

• Sizes for concentric circles and degrees are already chosen for you so it may be more limiting.

Creating a mandala base freehand

1. Start by finding the center of your page. Using your pen draw a center dot surrounded with your center circle pattern.

2. Continue drawing a pattern in the inner band with your pen.

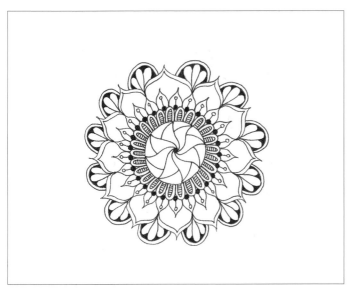

3. Add the patterns for the middle and outer bands.

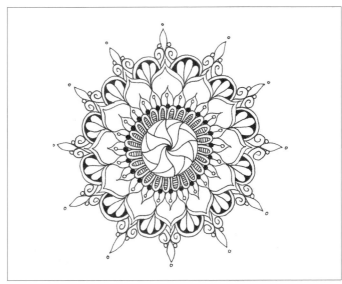

4. Finish with the border pattern.

Pros

- There are no pencil lines that need to be erased.

- There is no need for any materials other than your chosen card and a pen.

- It's a more spontaneous way to work and can allow your creativity to flow.

Cons

- Without a grid there isn't as much accuracy and symmetry as there would be when using a base template or grid laid out with either a stencil or compass.

- More care is needed to produce consistent repetitive patterns in a circular fashion.

TOP TIP

Make sure your pencil is really sharp when drawing or adding shading so you have more precision with your lines and placement.

Chapter 3
The next steps

In this chapter I will show you how to fill in the substructure you created in the previous chapter, and discuss shapes, center, and border pattern ideas. You'll also learn how to "grow" your mandala, how to vary line weights and about combining patterns.

Geometric shapes

This page shows a variety of geometric shops and how you can draw them so they can be included in your pattern making.

Geometric patterns are squares, circles, triangles, hexagons. They are made up of straight lines, angles, and points and are usually symmetrical, uniform, solid, and regular.

Slow down and breathe

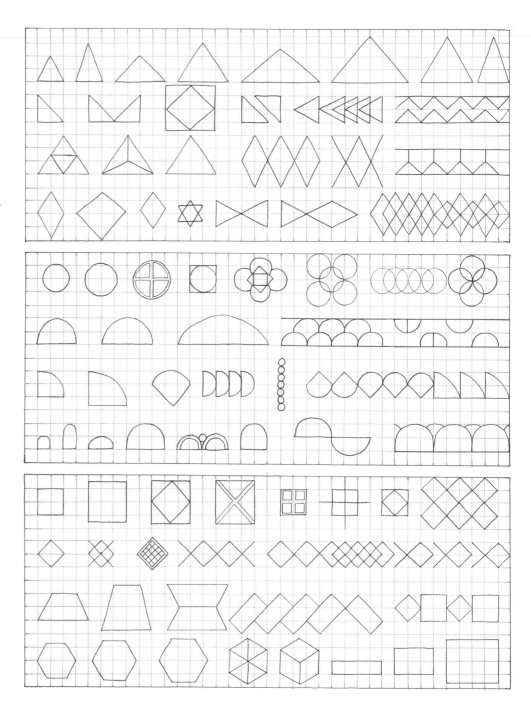

Organic shapes

This page shows lots of natural, organic, botanical shapes that you can use when drawing your patterns. Organic shapes are natural, irregular and asymmetrical and can be found in nature, flowers, spirals, loops, petals, leaves, drops, seeds and dots.

Geometric and organic shapes complement each other and are easy to combine, try adding a flower shape inside a triangle or square or add spirals inside a semicircle.

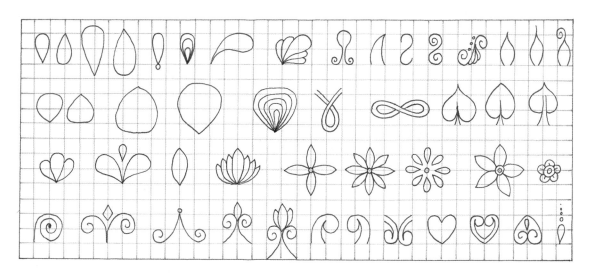

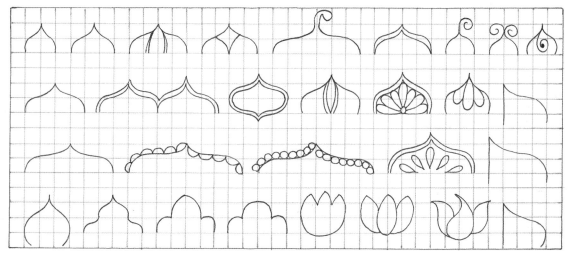

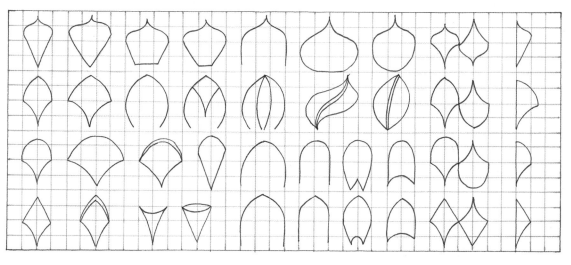

Center examples

On these I have drawn a variety of patterns for filling the center of your mandala substructure. I have grouped them into designs suitable for beginners, intermediate and more advanced.

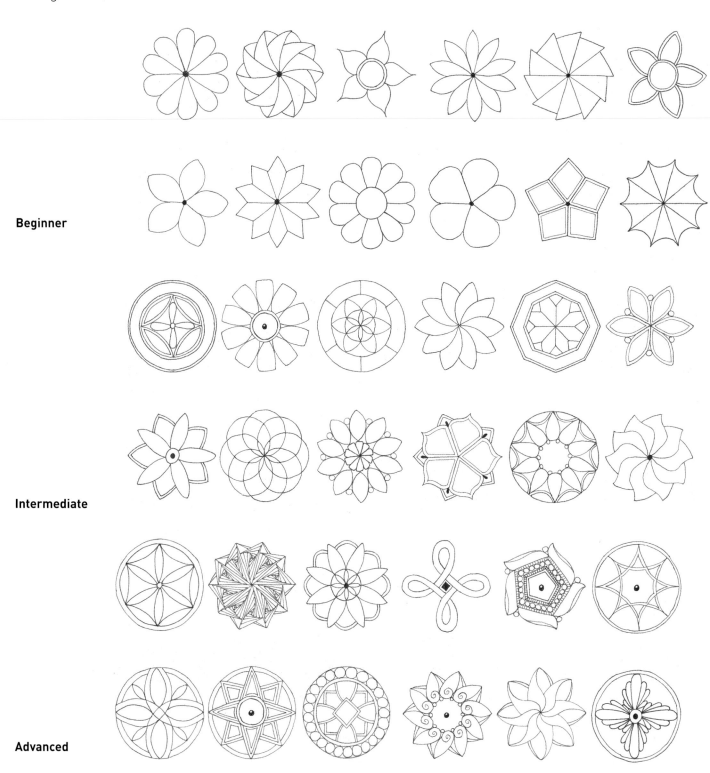

Beginner

Intermediate

Advanced

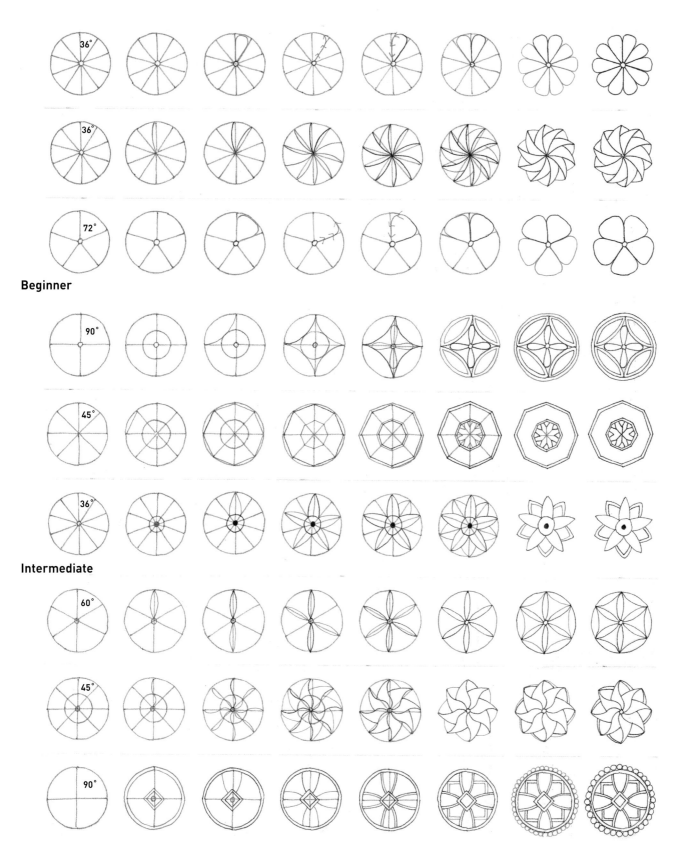

Beginner

Intermediate

Advanced

31

Borders

This page shows several examples of border patterns broken down into steps for you to follow. The completed examples are on the left-hand side, with the steps on how to draw them on the right-hand side.

As the border is the final part of the mandala you can either choose patterns that open it out or choose a more closed off pattern which will give it a solid boundary—for example a large solid circle that will enclose the whole piece.

This is down to personal preference and I find that when I'm drawing I don't think too much about it but draw the border then stand back, look at the piece and decide if it looks finished or needs something else.

Sometimes I will draw a closed solid circle around the border then add either dots or teardrop shapes outside the circle which will make the piece feel lighter. The other option is to scan and print a copy at this point then you can add a different border and compare the two to see which you prefer.

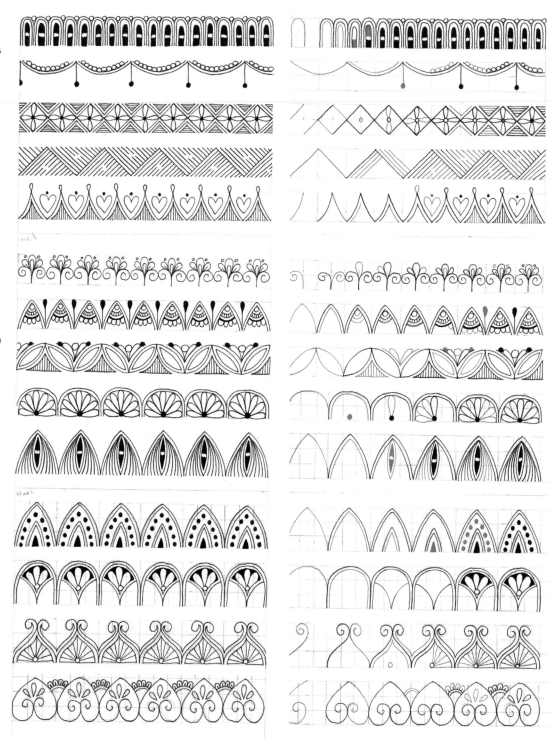

Practice sheets

Create your own practice sheets so you can choose your basic outer shape. By drawing and repeating the shape you will improve your muscle memory and be able to produce a more accurate representation when you start to draw your mandalas. I prefer to draw the right-hand stroke all the way around inside the chosen band first and then start again, but this time draw the left-hand stroke and when I've drawn both sides, I'll draw the elements inside the shapes created. The more you practice, the better you'll be able to find out the method that works the best for you.

In these examples I've shown how I set up my pattern sheets. As I use smaller segments near the center that get larger as I move outwards through the bands, I start with a 0.4 x 0.4 in (1 x 1 cm) box, moving up to 0.8 x 0.8 in (2 x 2 cm). As some of the filler elements are more intricate, I create some boxes with 0.2 in (0.5 cm) marked inside to give me a point of reference when replicating the patterns on the other side. So if I'm drawing a spiral on the inside, I want the left-hand spiral to mirror the shape and size of the right-hand spiral. Having the 0.2 in marked helps me to get them as close as possible.

In the photo of my pattern workbook, I've chosen to use a standard triangle but by varying the width of the base and the height of the outside of the triangle I have created a different effect. A wider base and taller triangle will leave more space to add an intricate filler pattern. I use my workbook to play and practice so I then have a bank of preferred pattern sizes and fillers for when I draw my mandala pieces.

I draw a selection of outer shapes varying the bottom widths, the heights and line weight on one side of the page, then on the opposite page I'll draw the same-sized outer shapes and lots of different fillers. I can then look at them together and choose designs I like from each section and draw three or four to see how they look together. I then try out the chosen outer shapes with the fillers to see what my final pattern will look like, then add it to my mandala piece.

As the workbook fits into a purse, I take it everywhere I go, and it's great for passing the time on long journeys.

At the end of the book on pages 92 and 93 there are two practice sheets that you can photocopy and use for your own designs.

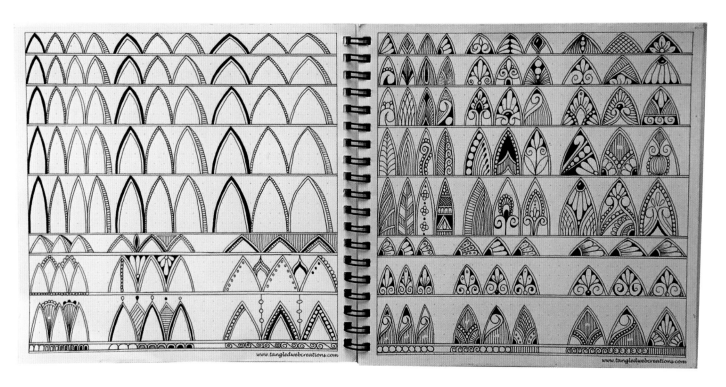

www.tangledwebcreations.com

TOP TIP

Create your own 'practice sheets'. These can be in a note book on plain, dotty or squared paper and act as a place where you can play with line weight and pattern making.

Playing with lines

Fine liner pens come in different colors and with a variety of different sized nibs ranging from the very fine 003 and 005 to the standard sizes such as 01, 02 and 03, the much thicker nibs of 05 and 08 and the very thick nib of the 1. Using different nib sizes to draw your pattern outline and the elements for the pattern fillers will change the look of your mandala. Varying the thickness of your lines and the distance between them will give different effects and convey depth, dimension, movement and flow.

When holding your fine liner pen hold it in the "Tip grip" position where your fingers are closer to the nib end rather than further down the barrel. This will give you more control and accuracy when drawing precise lines and patterns. Rest your hand and little finger on the page to give you a good support and allow you to pivot when drawing.

By changing the angle of the nib to the page you will be able to vary the pressure when drawing which will affect the amount of pressure applied. Don't hold the pen or pencil too tight as it can cause strain on your hand, fingers, and wrists.

It needs to be firm enough to have control when drawing intricate strokes, but not so rigid that you end up in discomfort or pain.

The boxes in the diagram below show the difference between using different thicknesses of nibs from 005, 01, 05 and 0.8. Each different nib size and the distance between the lines produces a different effect and once you have practiced you will find which you prefer.

The examples in the boxes show each of the methods with the lines first drawn very close together, then slightly further apart, and further apart again. The final box shows the layered effect.

1. Hatching

2. Cross-hatching

3. Stippling

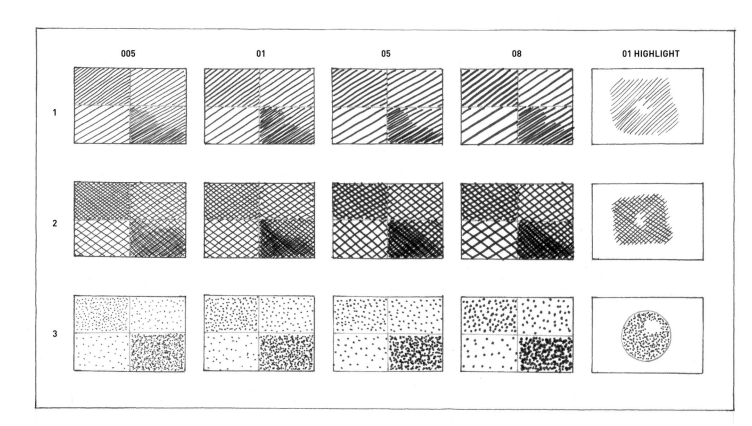

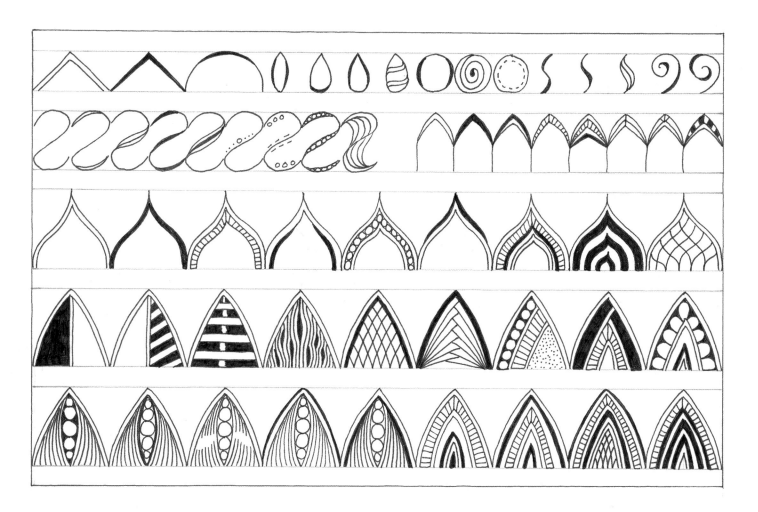

In the example above I've shown how, by varying the thickness of the lines, adding a repeating line or other small accents, you can change the look of the pattern outline and the elements for the fillers.

Some patterns will look better with solid black lines and others will look better with two lines drawn close together but as there isn't a right or wrong way to draw patterns it will be down to which you prefer.

By playing with lines, nib size and other accents you will learn how to enhance your patterns and fillers to add to the overall effect of your mandalas. You can either choose to fill in the solid lines as you go or wait till the end when all the bands and border have been drawn, then look at the piece and decide where you want the solid lines to balance out the whole. This will come with practice.

Some of the patterns that you select will have more space which will make the design look lighter and some will be more complex and leave little white space showing. I like the idea of balance, so when applying that to my pieces I sometimes opt for alternating patterns in each band, with a pattern that is darker then lighter then darker.

TOP TIP

When using a pencil to add shading I prefer to use a 2HB and a tortillion to smudge.

Growing your mandala

The examples on these pages use five concentric circles which have been divided the into quadrants. A pattern has been drawn inside each of the bands with an example of the finished pattern in the bottom left-hand corner. Some people draw their mandalas by choosing patterns and filling a wedge across all the bands and then repeat round the other wedges; I prefer to complete a band all the way around then move onto the next band. With practice you will find the best way for you.

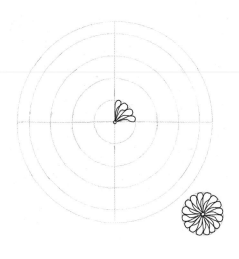

1. The chosen pattern for the center circle with a circle diameter of 0.4 in (1 cm).

2. The chosen pattern for the inner band with a circle diameter of 0.8 in (2 cm).

3. The chosen pattern for the middle band with a circle diameter of 1.2 in (3 cm).

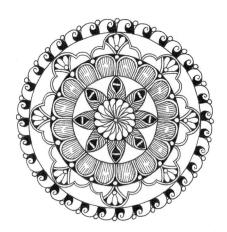

4. The chosen pattern for the outer band with a circle diameter of 1.6 in (4 cm).

5. The chosen pattern for the border with a circle diameter of 1.8 in (4.5 cm).

6. The completed mandala showing all the patterns used.

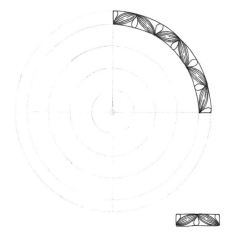

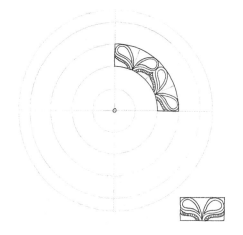

1. The center circle with a diameter of 0.4 in (1 cm).

2. The inner band with a circle diameter of 0.8 in (2 cm).

3. The middle band pattern with a circle diameter of 1.2 in (3 cm).

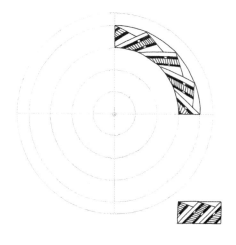

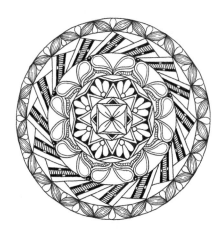

4. The outer band pattern with a circle diameter of 1.6 in (4 cm).

5. The border with a circle diameter of 1.8 in (4.5 cm).

6. The completed mandala showing all the patterns used.

TOP TIP

When drawing the patterns inside each segment, rotate your page as you go around that band as this will help you to get more precise lines into the meditative flow.

Combining patterns

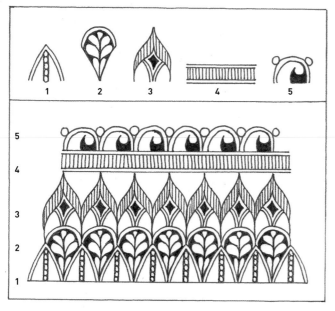

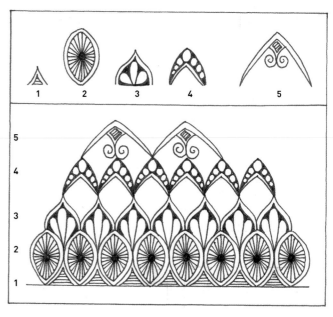

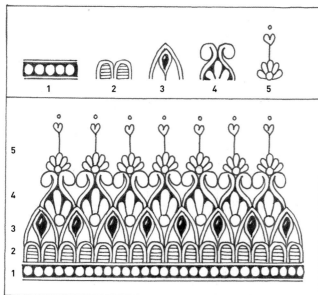

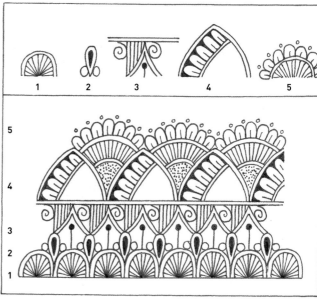

Combining patterns is all about creating layers, and adding different patterns on top of the previously drawn layer. Choose a pattern that fits into the natural area left between patterns, known as negative or white space. Use the inside and outside along with the patterns that sit on the same band as well as above and below. This will make the patterns and layers look seamless and flowing which gives the impression of movement and energy. Then by adding shading or color you can add another dimension to your piece. You can choose to use the negative space created, leave it blank or color it in so it's a feature.

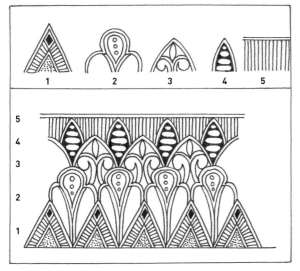

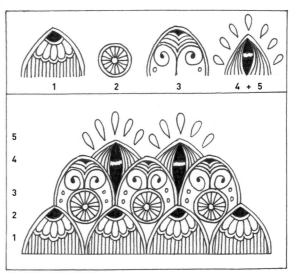

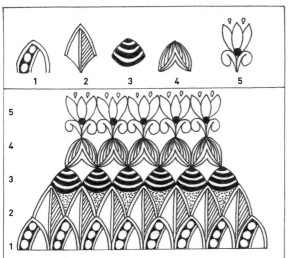

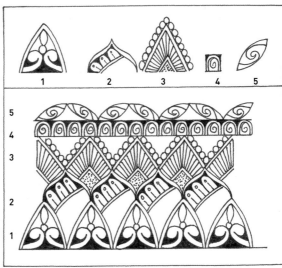

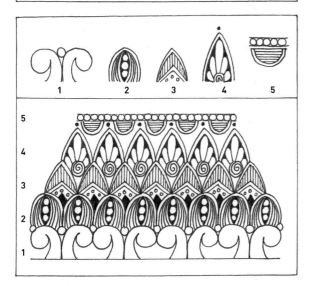

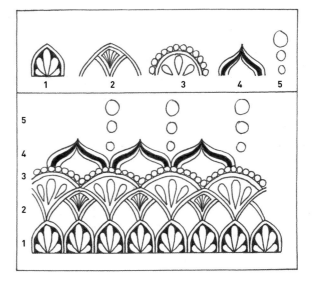

TOP TIP

When drawing each outer pattern, I prefer to draw an inner line which mirrors the same shape so there is some white space. It helps to make the patterns look cleaner, crisper and the filler elements inside to stand out more.

Design and planning

Mandalas are normally drawn intuitively inside a base substructure or template but sometimes I like to use a specific base design and add patterns inside. In this chapter I will show you five mandala designs and how to draw them.

Compass rose mandala

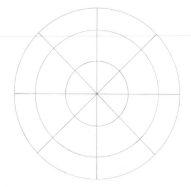

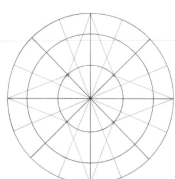

Step 1

Using the method shown on page 21 find the center of the page and make a dot in pencil.

Using a compass and pencil draw three circles measuring 0.4, 0.8 and 1.2 in (1, 2, and 3 cm).

Using a protractor, ruler and pencil divide the circle into eight segments each measuring 45 degrees.

Step 2

Using a protractor, ruler and pencil divide the circle to add more segments each at 22.5 degrees, totalling 16 segments.

Using a pencil and ruler draw lines from the 1.2 in (3 cm) circle marked "X" in red to form a triangle at north, south, east and west.

Step 3

Using a pencil and ruler draw lines from each point marked "X" in red to form a triangle.

Repeat to form three further triangles.

Step 4

Using a compass and pencil draw a circle measuring 2.2 in (5.5 cm) from the center point. I have drawn this circle only in the spaces around the eight larger triangles.

Using a pencil and ruler join the three marked "X" in red to form a triangle.

Repeat in each segment to form seven more triangles.

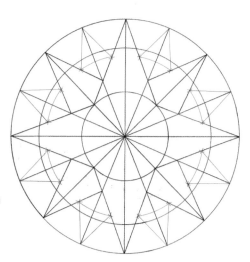

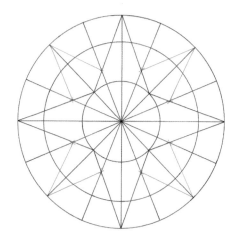

The base template is now complete and ready to add patterns in pen.

Once finished, erase all the remaining pencil marks and add shading in pencil if you desire.

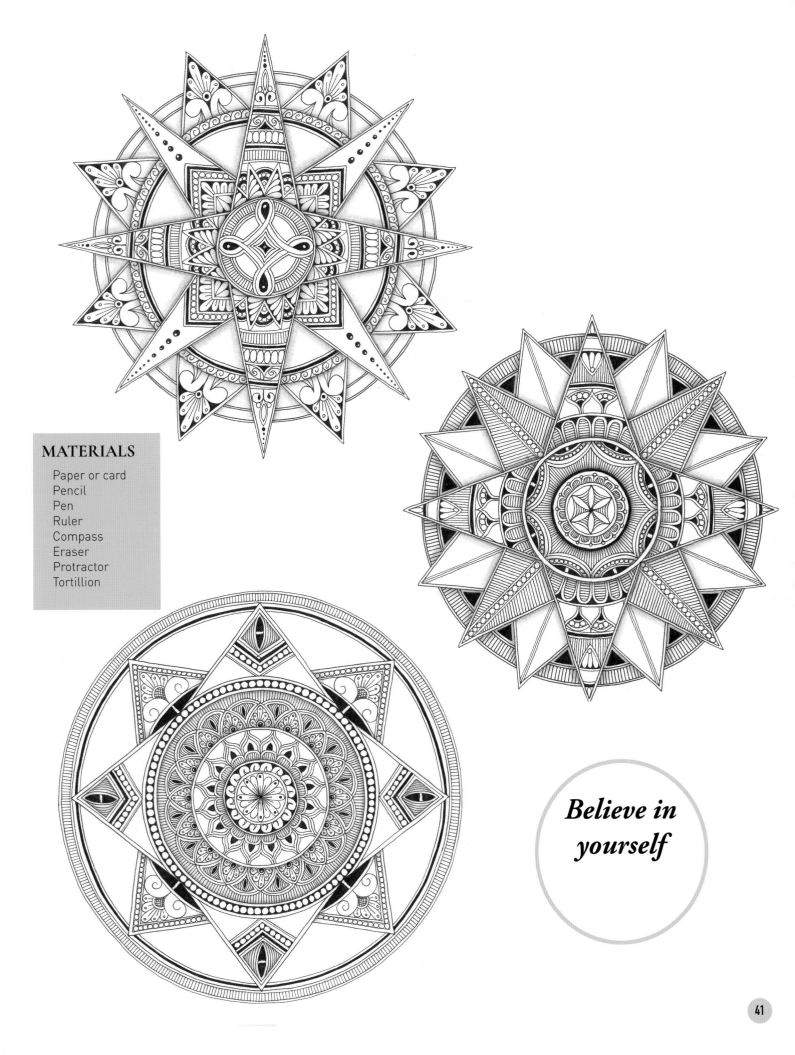

MATERIALS

Paper or card
Pencil
Pen
Ruler
Compass
Eraser
Protractor
Tortillion

Believe in yourself

Half-moon mandala

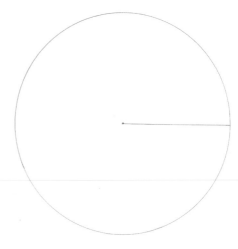

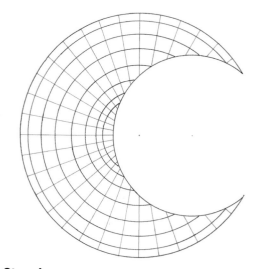

Step 1

Find the center of the page, make a dot and mark in pencil.

Using a compass and pencil draw a circle measuring 3.2 in (8 cm) across.

From the center point draw a straight line to the edge of the circle in pencil.

Step 2

Along the straight line drawn in the previous step measure and make a pencil mark 1.4 in (3.5 cm) from the edge of the circle.

Using a pencil, place the point of the compass at the 1.4 in (3.5 cm) mark and extend so the attached pencil measures to the center point and draw part of a circle stopping when you reach the edge of the large circle. This will form a crescent shape.

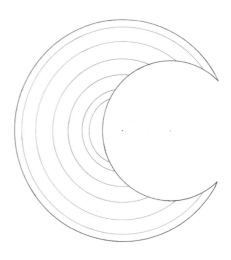

Step 3

Erase the straight horizontal pencil line and the part of the first large 3.2 in (8 cm) circle.

Using a compass and pencil set at the center point draw different sized concentric circles inside the 3.2 in (8 cm) crescent.

Step 4

Using a protractor and pencil mark every 10 degrees around the circle.

Using a pencil and ruler draw lines radiating from the center point to join the 10 degree marks.

The base template is complete and ready to fill with patterns in pen.

Once finished erase the remaining pencil marks and if desired add shading in pencil.

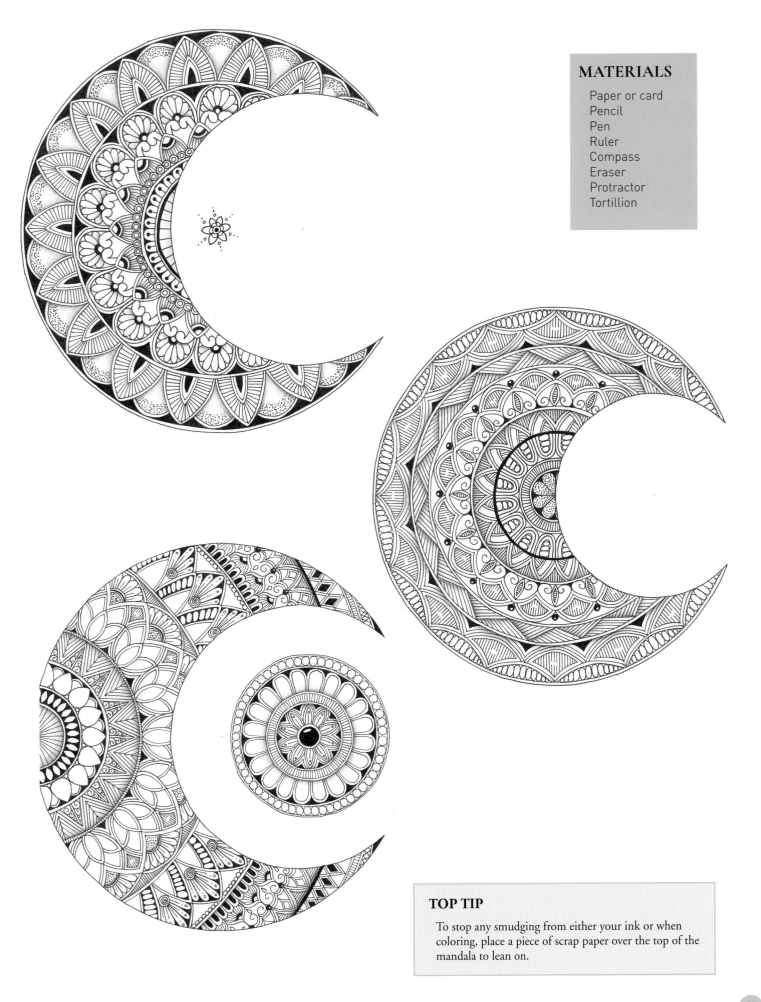

MATERIALS

Paper or card
Pencil
Pen
Ruler
Compass
Eraser
Protractor
Tortillion

TOP TIP

To stop any smudging from either your ink or when coloring, place a piece of scrap paper over the top of the mandala to lean on.

Sinkhole mandala

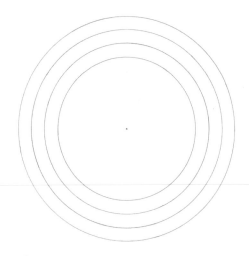

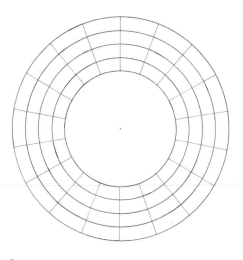

Step 1

Using a pencil find the center and make a dot.

Using a compass and pencil draw five circles. I've used circles that measure 1.6, 2, 2.4, 2.8 and 3.2 in (4, 5, 6, 7 and 8 cm).

Step 2

Using a protractor and pencil make a mark every 20 degrees.

Using a ruler join the marks made at 20 degrees inside the five circles using the center point as the anchor point.

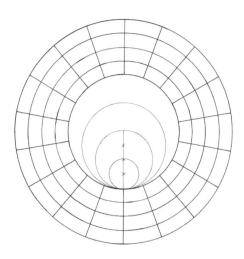

Step 3

From the center point draw a vertical line in pencil down to the smallest circle that measures 1.6 in (4 cm).

Using a ruler and pencil mark down this line at 0.4, 0.8 and 1.2 in (1, 2 and 3 cm).

Using a pencil and compass, set the compass point at each of the points marked along the with an "X" and draw a circle that stops at the edge of the 1.6 in (4 cm) circle.

Step 4

Using a ruler and pencil join the ends of each of the 20 degree lines marked with an "X" to the bottom center point of the 1.6 in (4 cm) circle.

The base template is now complete and ready for you to start adding patterns in pen.

Once finished erase all the remaining pencil marks and add some shading in pencil mostly around the inside of the smallest 1.6 in (4 cm) circle to add depth.

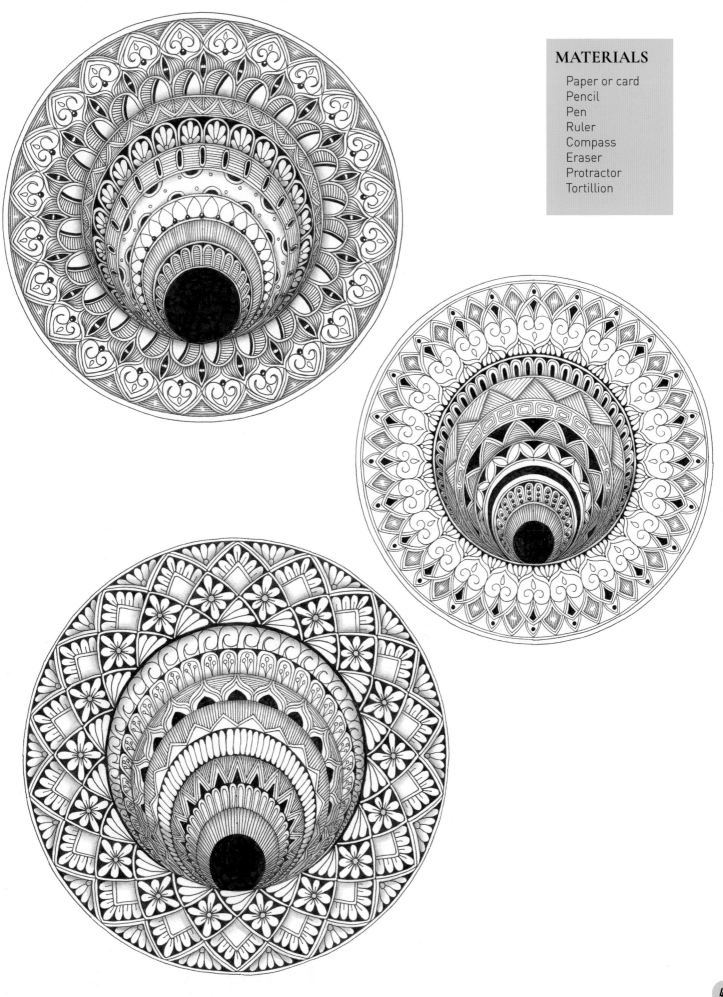

MATERIALS

Paper or card
Pencil
Pen
Ruler
Compass
Eraser
Protractor
Tortillion

Nine-circle mandala

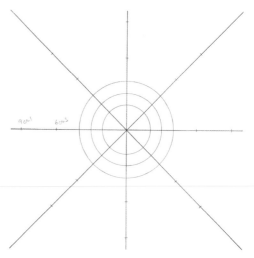

Step 1

Find the center of the page.

Divide into eight sections, 45 degrees apart.

Draw lines in pencil.

Step 2

Using a compass and pencil draw three circles from the center point, I've chosen at 0.8, 1.2 and 1.6 in (2, 3 and 4 cm).

Along each of the eight lines that are 45 degrees apart, mark in pencil at 2.4 and 3.6 in (6 and 9 cm).

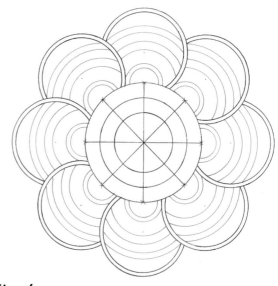

Step 3

Set the compass point at the previously marked points of 2.4 in (6 cm) and measure out so the pencil is at the 3.6 in (9 cm) mark and draw three-quarters of a circle.

Repeat till you have eight three-quarter circles.

Adjust the compass and draw another slightly smaller circle inside each of these eight three-quarter circles.

Step 4

Move the compass to the points marked "X" in red and add a variety of smaller concentric circles inside each of the eight outer three-quarter circles.

You can also add lines inside each of the three-quarter circles.

The base template is now complete and ready to fill in with patterns in pen.

Once finished drawing in pens, add some shading, if desired, then erase the pencil marks and add shading in pencil.

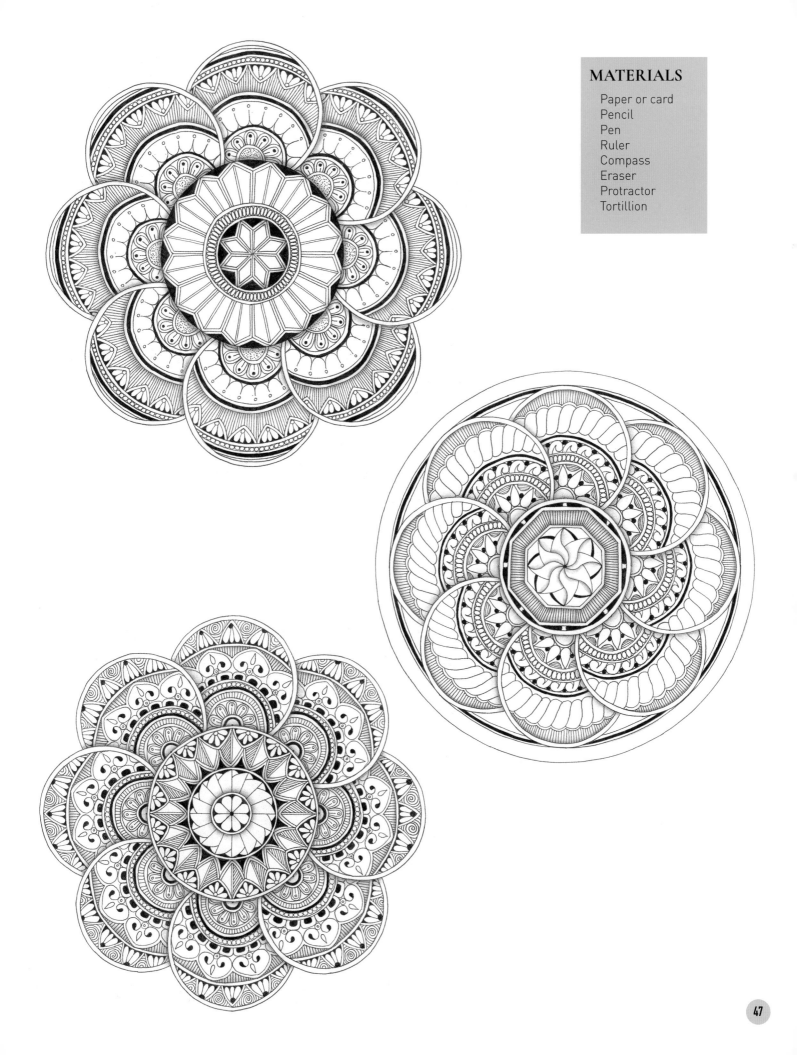

3D mandalas

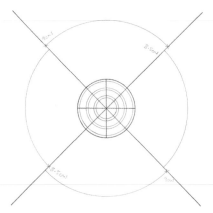

Step 1
Find the center of the page and draw line from top left to bottom right corner then repeat and draw another line from top right corner to bottom left corner. Measure and draw a circle: this one measures 1.2 in (3 cm). Divide into equal sections and draw lines inside this circle only, I've chosen eight segments.

Step 2
Using a ruler and pencil measure along one of the diagonal lines and mark at 3.6 in (9 cm) from the center point, repeat and mark on the same diagonal line but on the other side of the center point at 3.6 in (9cm) as shown in the picture marked "X".

Repeat on the other diagonal line but mark at 3.4 in (8.5 cm) either side of the center point.

Using a compass and pencil start from the 3.6 in (9 cm) pencil marks and draw a part circle round to the next diagonal line to form a quarter circle. Repeat at the other 3.6 in (9 cm) pencil mark where you will have two quarter circles on opposite sides. Then re-measure the compass to 3.4 in (8.5 cm) and repeat in the two remaining quadrants.

Inside the small 1.2 in (3 cm) circle draw more concentric circles, I've chosen to add five circles.

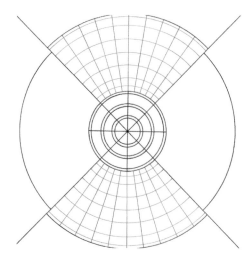

Step 3
Using a compass and pencil draw a selection of different sized concentric circles inside the two larger quarter sections. Then divide these two sections into equal segments. I've chosen ten segments.

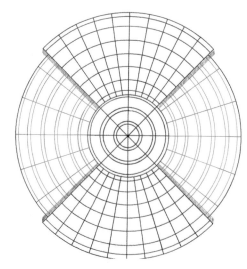

Step 4
In the final two quarter sections draw another batch of concentric circles but try to make them a different size to the concentric circles in the other two quarter sections. Then divide into equal segments. I've chosen six segments.

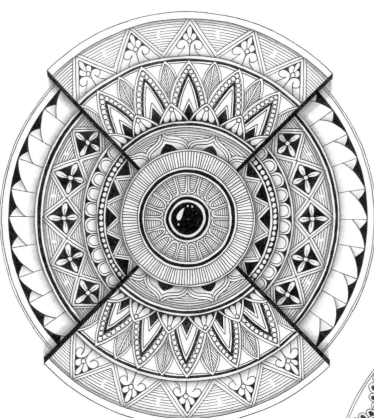

MATERIALS

Paper or card
Pencil
Pen
Ruler
Compass
Eraser
Protractor
Tortillion

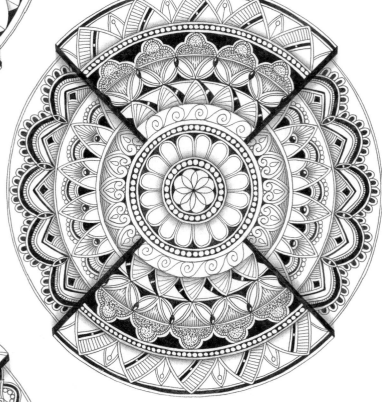

Your base template is now ready to start filling with patterns. Once finished, erase all remaining pencils marks and add shading in pencil.

When the sections have been filled with patterns and the mandala is complete I add a thick dark line of black pen and pencil shading along the parts where the smaller quarters meet the larger quarters; this helps to give a sense of depth. I've marked these sections in pencil on the example.

TOP TIP

When I finish my mandala I like to scan, print and save a copy for my file. This way if chose to add color at a later date I have a copy of the original piece.

Chapter 5
Pattern library

You can create a pattern library using either a notebook or individual pages which can be placed into a binder. I prefer to use a ring bound notebook as it sits flat and will fit into my purse when I travel. I like to create a purpose made notebook as you can use your preferred paper.

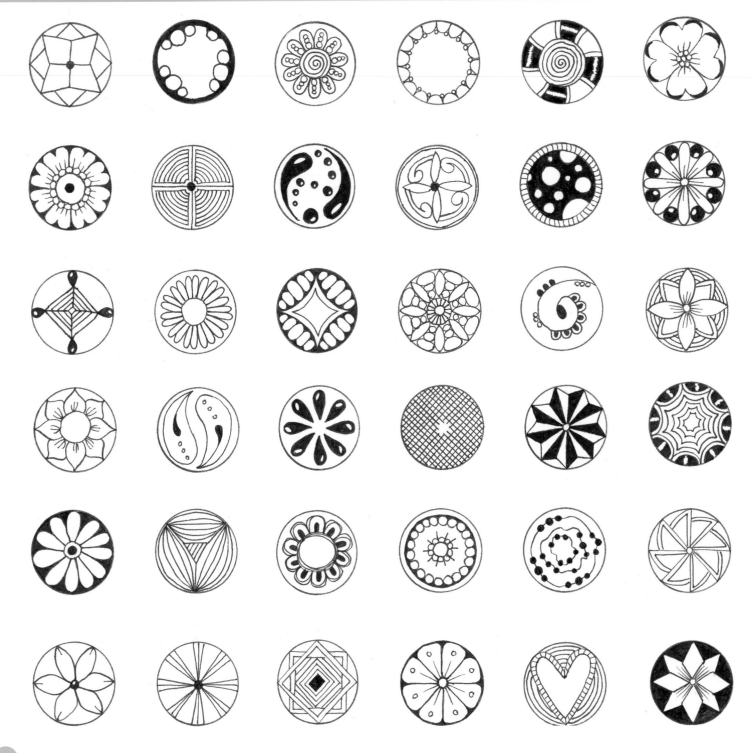

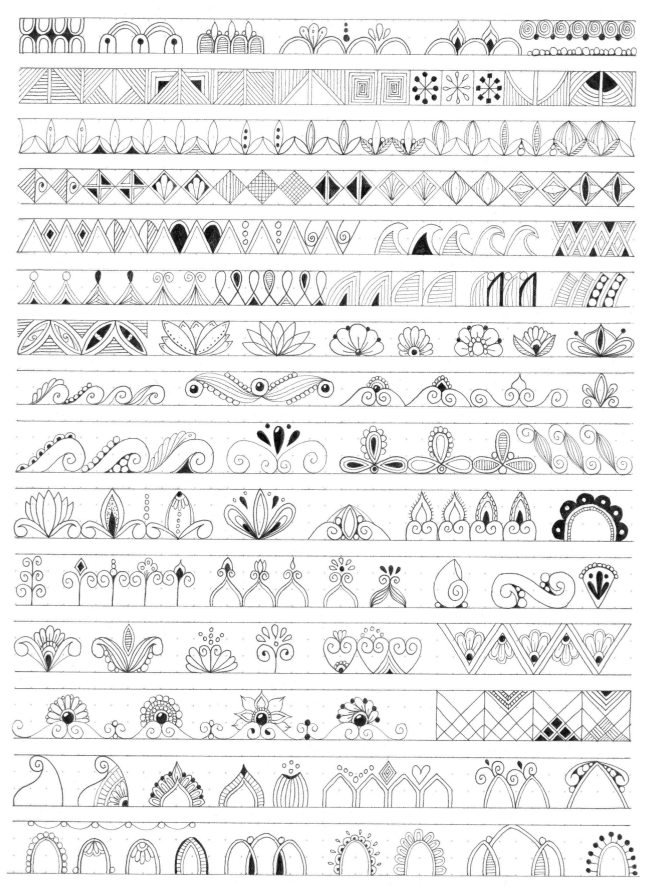

I use either paper with dots spaced at 0.2 in or grid spaced at 0.2 in. I use these papers instead of plain or lined paper as it helps me to practice my strokes, placement and mirroring the patterns on the left and right hand side. As the dots and grid are in a light gray color they almost disappear into the background.

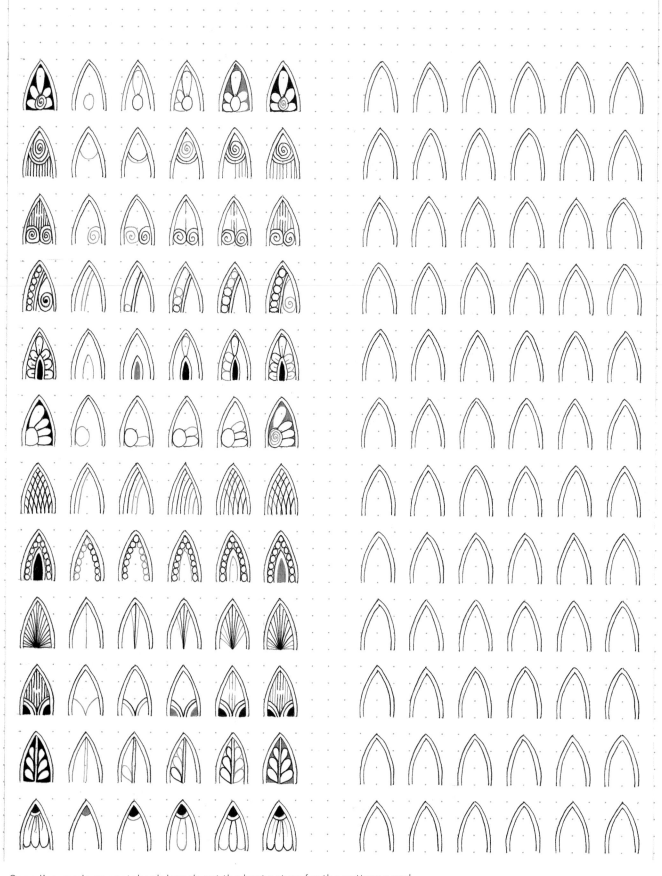

Once I've made my notebook I work out the best set up for the patterns and measure both the height and width which will help me to work out how many rows I need. I don't draw these grid set ups on more than a couple of pages as I may change my mind later in the book and choose to draw my patterns larger.

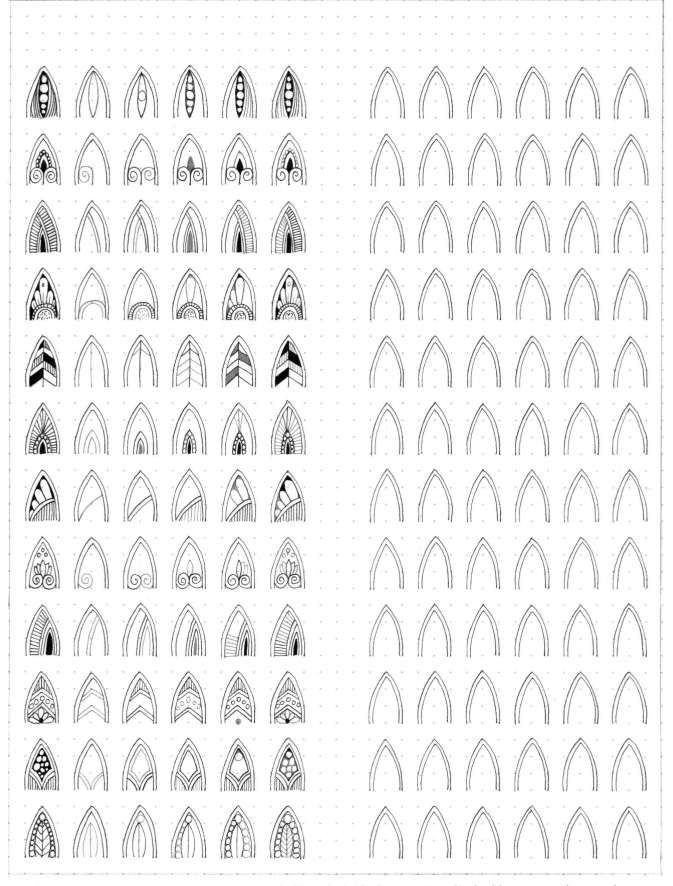

As I travel a lot I take my pattern book with me everywhere, and practice completed patterns, deconstruct patterns I see and, where I can play around, practice my strokes, try new patterns, elements, and motifs. There is a template for these on page 91 at the back of the book.

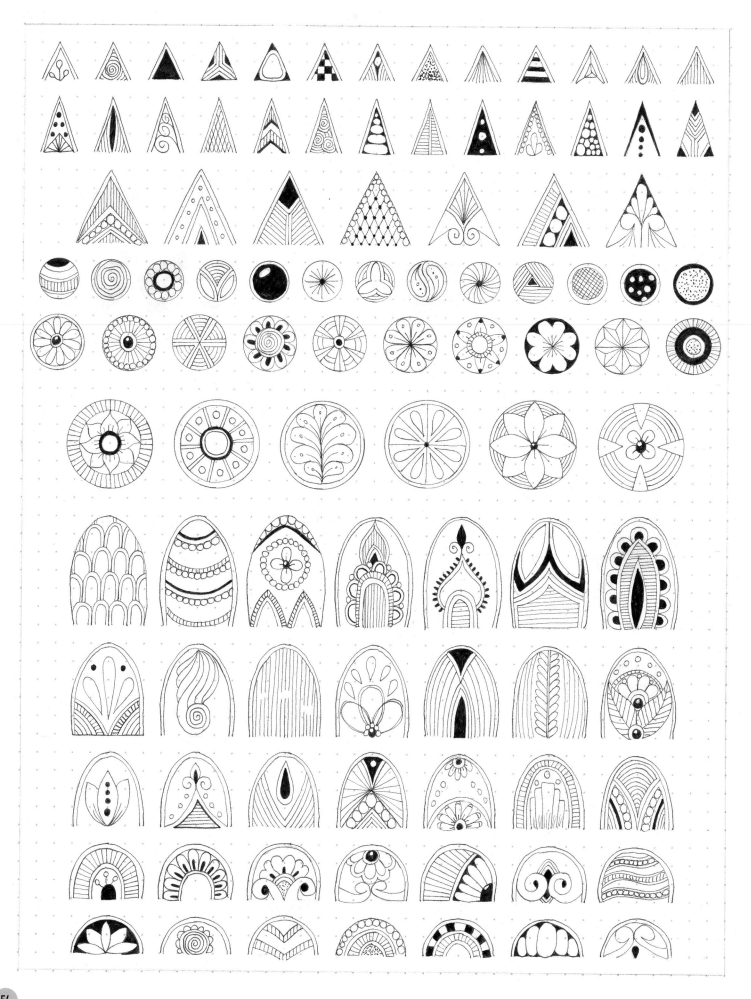

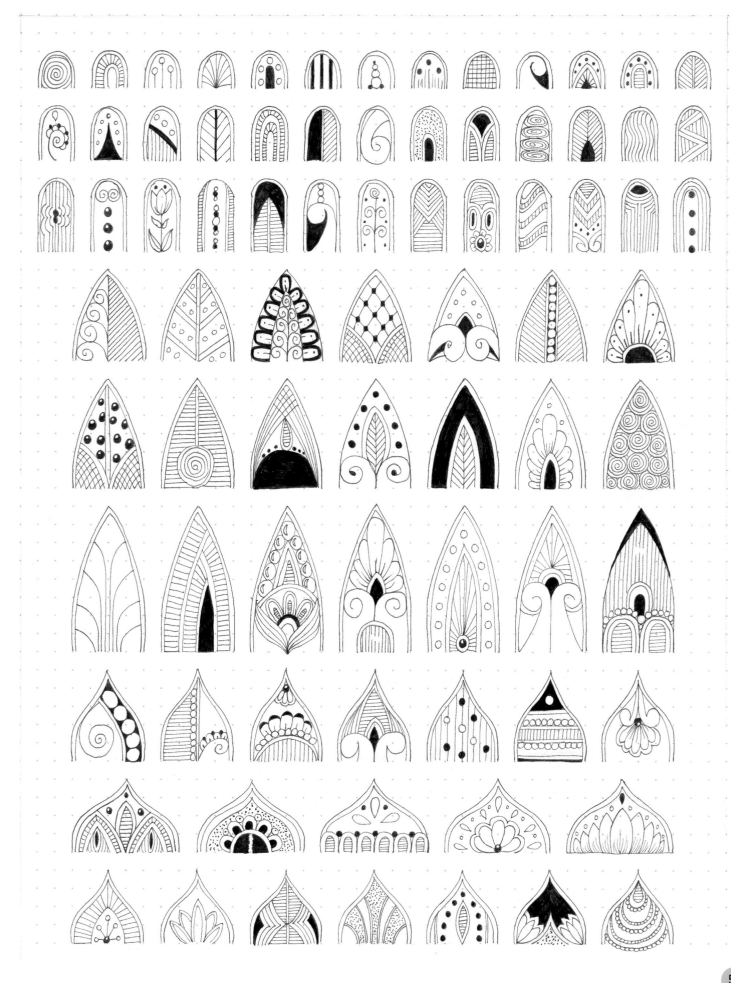

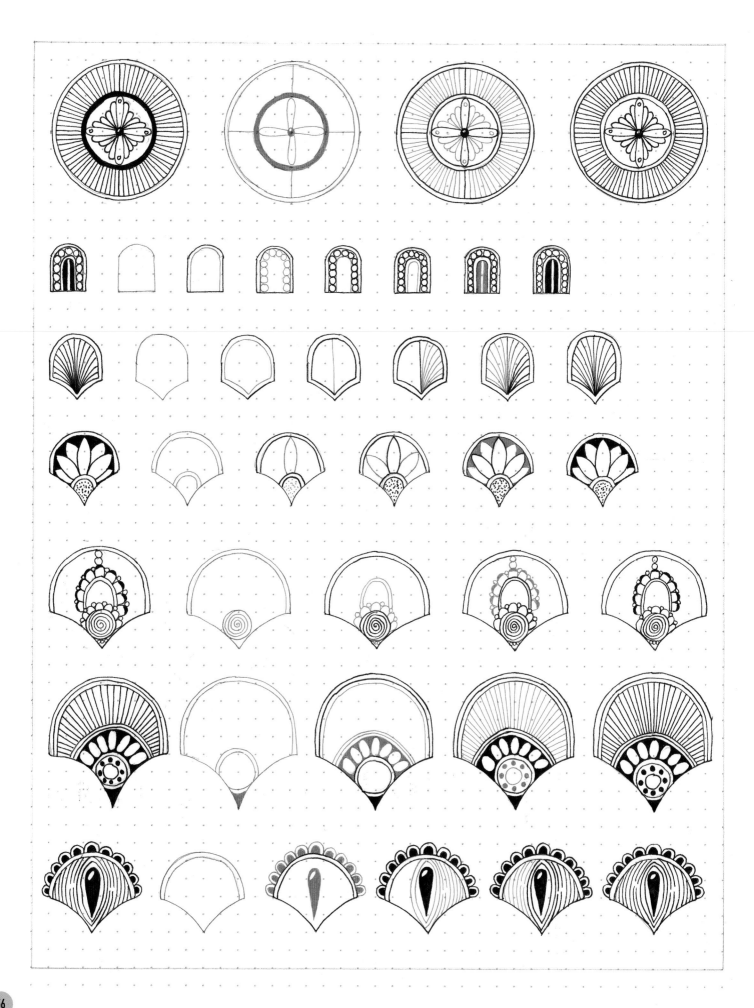

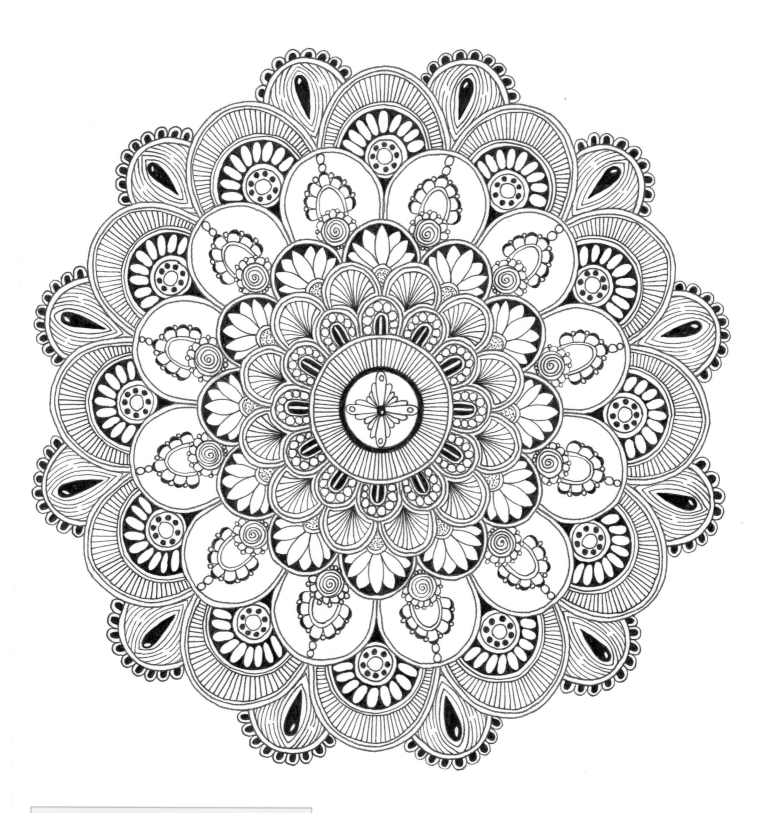

TOP TIP

Create a 'pattern library' for your own patterns, shapes and designs so you can refer to it if you need some inspiration.

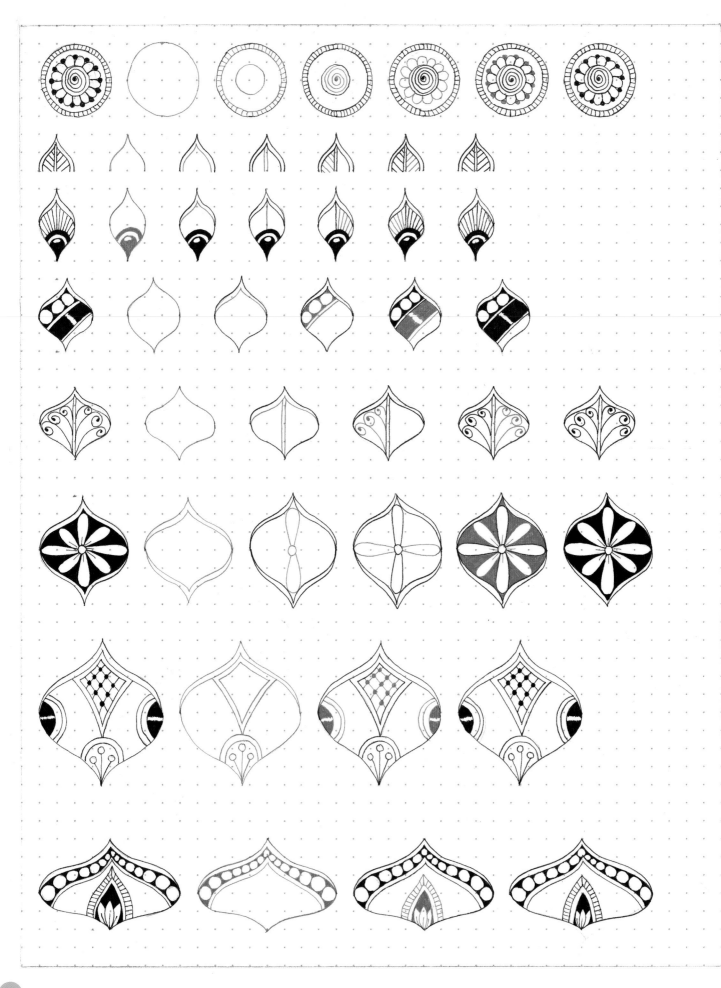

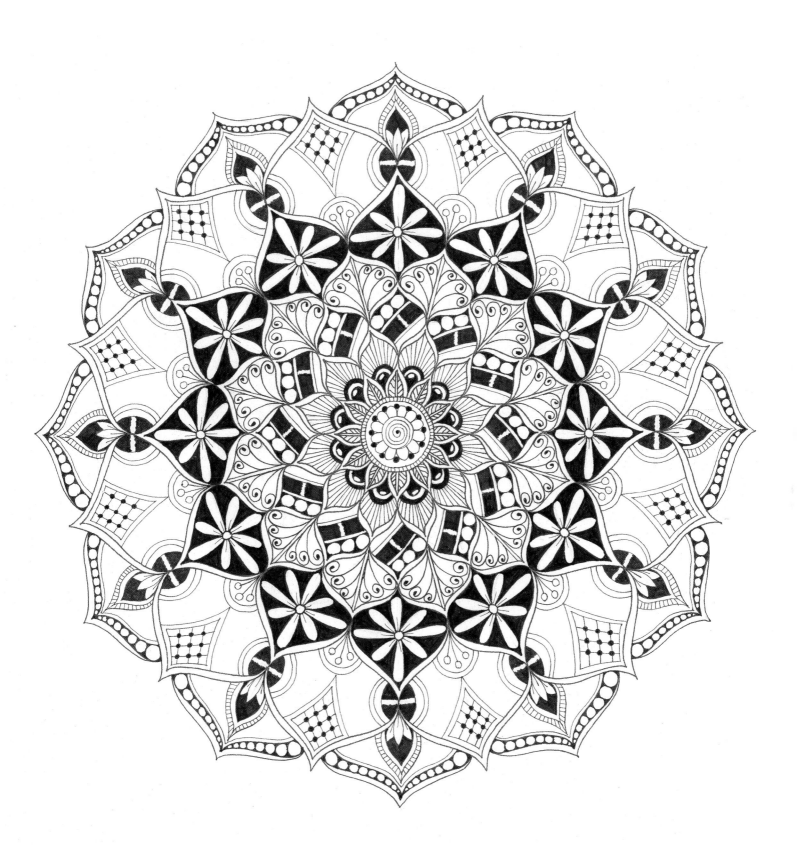

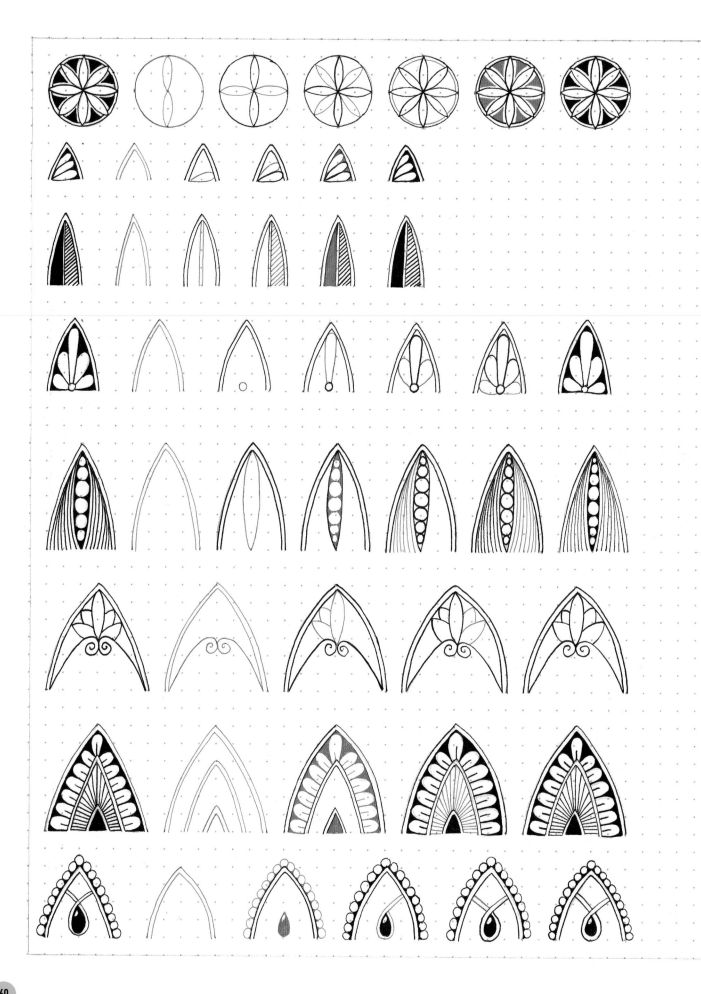

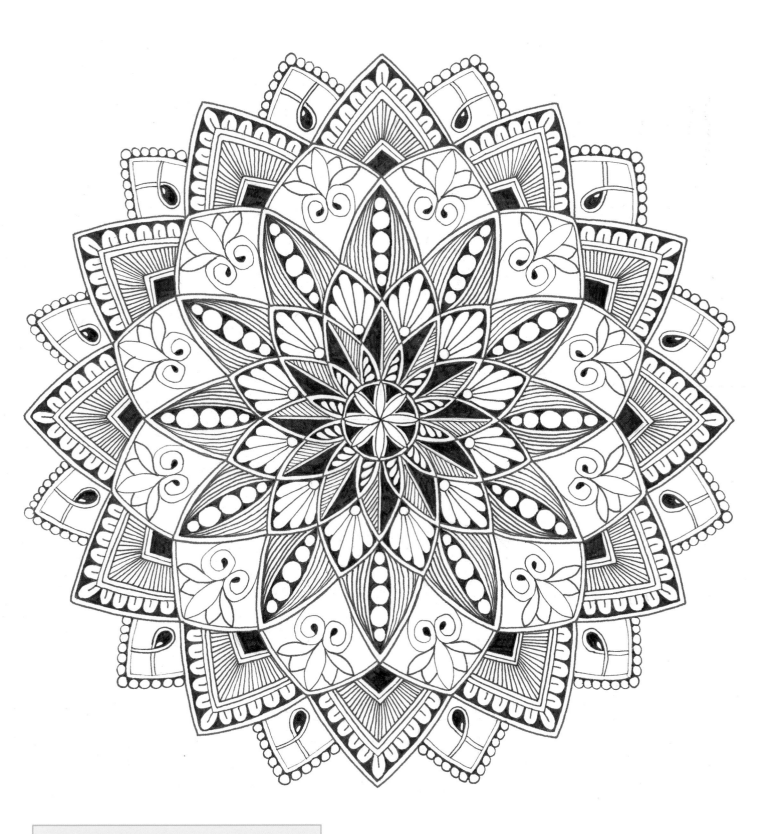

TOP TIP

Look at mandalas, patterns, and designs online, find styles that you like and add to your pattern library.

Balance and harmony

Over the centuries artists and designers have used the color wheel to choose color palettes. It is used to create pleasing interior schemes, fabrics, paintings, and garden plantings. Understanding how to use it will improve your artwork too. You can make your own 12-part color wheel as I have done here, or purchase one at any art suppliers.

Defining colors

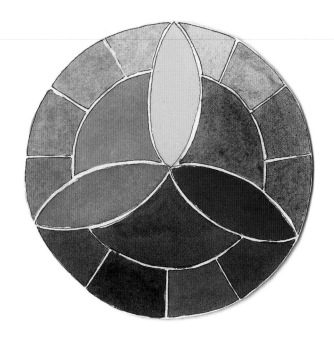

There are some definitions you need to know before we look at the harmonious color palettes we can put together.

Primary colors

Red, yellow and blue

In traditional color theory (used in paint and pigments), primary colors are the three pigment colors that cannot be mixed or formed by any combination of other colors. All other colors are created from these three hues.

Secondary colors

Green, orange, and purple

These are the colors formed by mixing the primary colors. Yellow and blue = green; red and yellow = orange; blue and red = purple.

Tertiary colors

Yellow-orange, red-orange, red-purple, blue-purple, blue-green, and yellow-green

The color produced by mixing a primary and a secondary color. That's why the hue is a two-word name.

Hue, tint, shade, and tone

• A **hue** refers to a dominant color family, ie a blue hue leaning strongly toward red.
• A **tint** is a color with white added.
• A **shade** is a color with black added.
• A **tone** is a color with both black and white added.

Choosing three to five colors is usually most pleasing using the following proportions:

• Main color 60%
• Neutral 30%
• Accent color 10%,

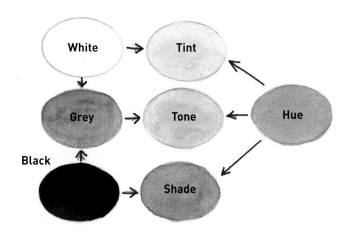

Formulas for harmonious schemes

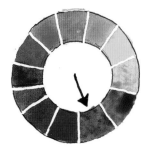

Monochromatic schemes consist of varying tints and tones of only one color. These color combinations create a calm, serene feeling.

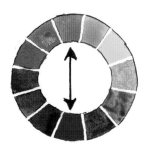

Complementary schemes consist of two colors which are directly opposite each other on the color wheel, for example red and green, orange and blue, red-purple and yellow-green. These opposing colors create maximum contrast and maximum stability.

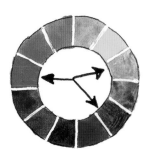

Split complementary schemes consist of your chosen color and those that sit either side of the opposing complementary color. The example here uses red paired with yellow-green and blue-green. This creates a loud, exciting combination.

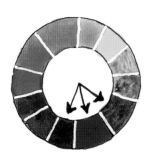

Analogous schemes are any three colors which are side by side on a 12-part color wheel, such as yellow-green, yellow and yellow-orange. Usually, one of the colors predominates. As these colors are closely related on the color wheel, they have a harmonious appeal.

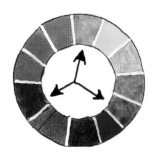

Triad schemes consist of three colors that are positioned equidistantly on the color wheel, for example, orange, purple and green, or red-blue, blue-green and yellow-orange. A set of triadic colors can be interesting and vivacious.

Choosing a color palette

You have now drawn your mandala and want to apply color. How do you pick a color palette that will work beautifully?

Visit a paint shop or DIY store and help yourself to some of their paint chip samples in your favourite colors. Now sit with a pile of magazines, wrapping paper and old birthday cards. Flick through these and cut out any pictures that have colors that you really like. Then follow the steps below to create a color palette for your mandala. This will give you greater confidence to put colors together and increase the chance of you loving your mandala when it is finished. Give it a try and see what happens.

A selection of paint chips

Step 1
Find a picture that has the feel that you'd like to create on your mandala. Look for the colors that you would like to use. Choose a paint chip which is the same as one of the colors and glue it on. I chose a powder pink chip for my floral picture opposite.

Tear out pictures and colors that appeal to you.

Step 2
Now sort out your pencils, matching them to the colors in the picture. Isolate each color in turn, coloring in one of the five stacked boxes and make note of the pencil number for later reference. You now have your five chosen pencil colors for your color scheme. If using watercolors use a scrap of paper to check you have mixed the right color before filling in your boxes.

Step 3
Now work out how to balance the many possibilities open to you. You have five areas labelled A–E (see opposite) that you are going to use to see how the colors behave in different proportions. As you can see, this column has been broken into different sized areas. Use all five colors in each column in different places.

Step 4
Now look carefully at each of the columns and decide which looks most pleasing to you. This will tell you the proportions of each color to use to create your scheme.

Step 5
These five colors form your palette. You can use them all at full strength or you can mix them with black and white to create tints and tones. This is easier to do with watercolor than pencils. The sets of four boxes are the tints and tones I mixed from my five full strength hues.

Applying different colorways

Below is a basic mandala using four different colorways. The top left quarter uses the proportions in scheme C, top right is based on A, bottom left on B and bottom right on scheme E. They are each very different but equally beautiful.

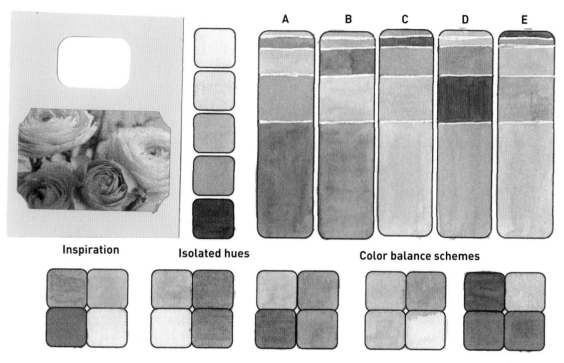

Inspiration Isolated hues Color balance schemes

A B C D E

Tints and tones mixed from my chosen hues

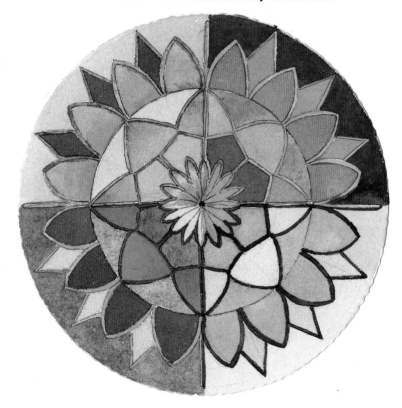

Vivid colorways

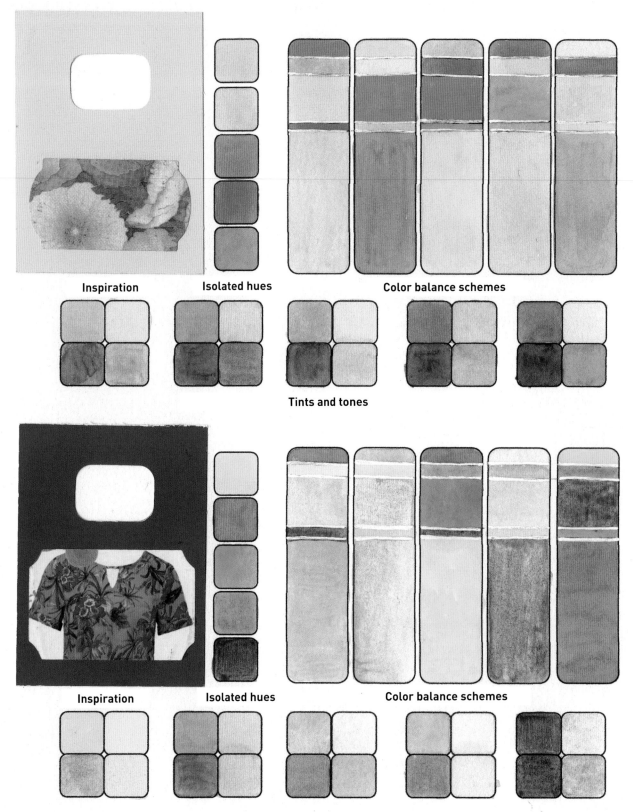

Inspiration　　Isolated hues　　Color balance schemes

Tints and tones

Inspiration　　Isolated hues　　Color balance schemes

Tints and tones mixed from my chosen hues

Softer colorways

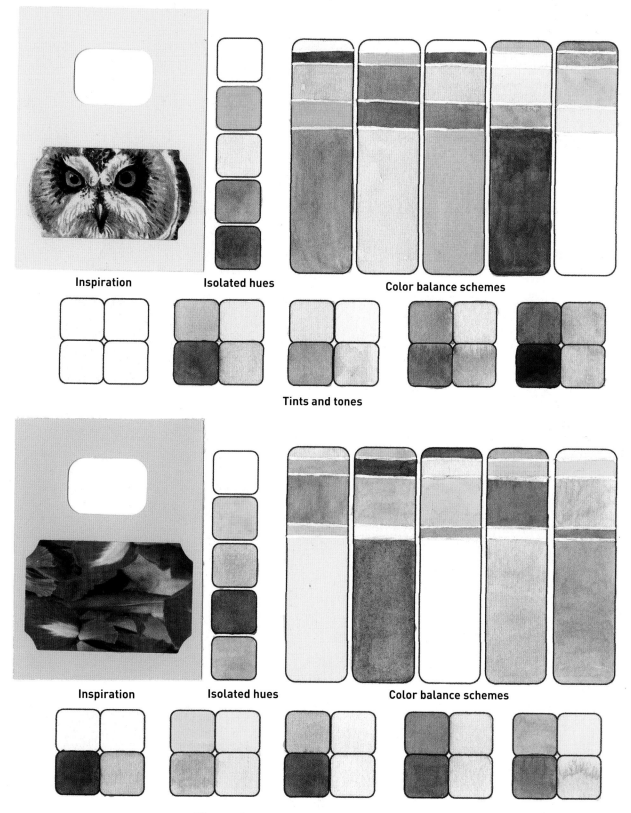

Inspiration

Isolated hues

Color balance schemes

Tints and tones

Inspiration

Isolated hues

Color balance schemes

Tints and tones mixed from my chosen hues

Chapter 7
Projects and inspiration

I have created mandalas on a wide variety of items and love to find new and interesting ways to add other mediums to my pieces. In this chapter I will show you some examples of items I have made with my designs and how I have added a little extra touch with some gift and card ideas.

Bookmarks

1. Take a sheet of white card and make a watercolor background for each bookmark using Koi brush pens.

2. Measure and cut the card to fit the black card.

3. Decide on the orientation for each mandala on the bookmark and using a variety of colored pens draw some mandalas.

4. Apply glue to the back of the white card and stick onto the black card stock.

5. Make individual coordinating tassels out of wool and draw them through the metal eyelets.

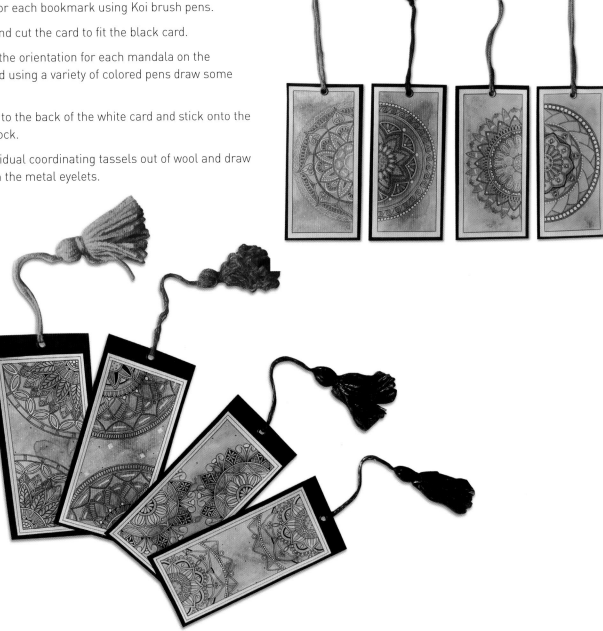

Artists' trading coins

Artist trading coins are similar to Artist trading cards which are miniature pieces of art that can be collected and swapped. They are hand crafted and are sometimes designed in sets of three, with a theme for each set and an inspirational quote or words. ATCs are dated and signed on the reverse and can include a number or more artwork.

Set 1 Purple

1. Cut 2.5 in (6.3 cm) circles from thick card.

2. Create three pages of watercolor wash backgrounds.

3. Use a 2.5 in (6.3 cm) circle punch to cut the individual coins.

Set 2 Pink

4. Then use fine liners and Gelly Roll pens to draw unique mini mandalas.

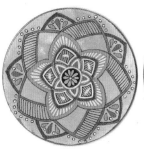 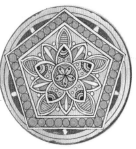 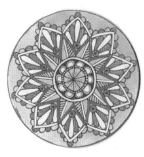

Set 3 Green

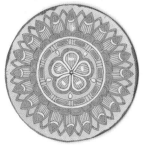

5. Stick them to the circles of thick card.

6. Leave overnight beneath a heavy book and finish by adding small accents as decoration.

Set 4 Orange

Postcards

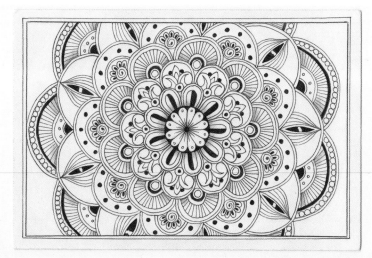

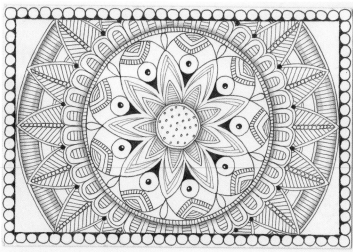

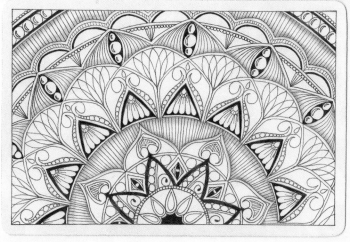

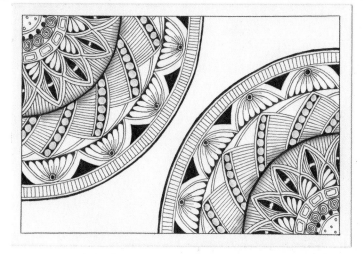

1. Cut white 250 gsm card into postcard sized shapes – about 6 x 4 in (15 x 10 cm).

2. Draw a mandala on the front of each postcard in black ink. You can do a variety so no two postcards are the same.

3. Finish off the mandala with shading.

4. If you like, add address lines and a placement for a stamp on the back of the postcard.

Greetings cards

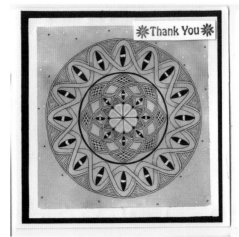

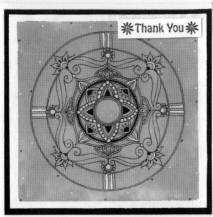

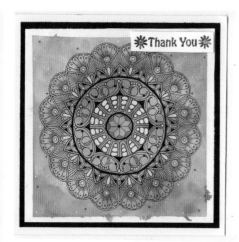

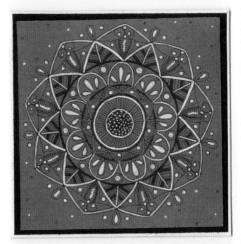

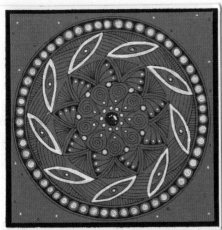

1. Use white, brown and grey 250 gsm card stock and cut to size as a 'topper'.

2. Cut cards out of white 250 gsm card.

3. On the white card make a watercolor wash background.

4. Using fine liner pens draw a mandala on each topper. You can do a different design for each one (Make sure the watercolor is fully dry before drawing on it.)

5. Finally, mount and glue the toppers to the cards.

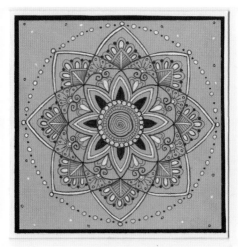

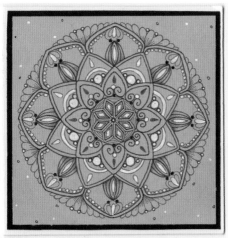

Candles

1. You can buy white wax candles in a wide variety of sizes.

2. Draw mini mandalas on white tissue paper using a black fine liner pen.

3. Carefully apply the tissue to each candle.

4. Finish off the candle by decorating with mini pearls and crystals.

Have fun and get creating

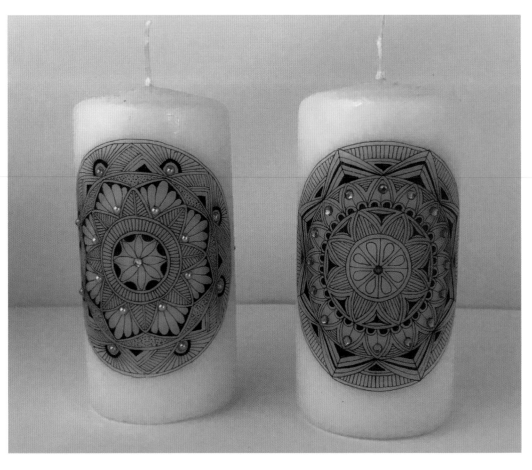

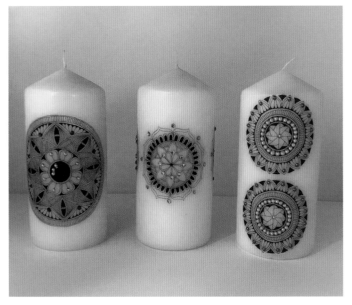

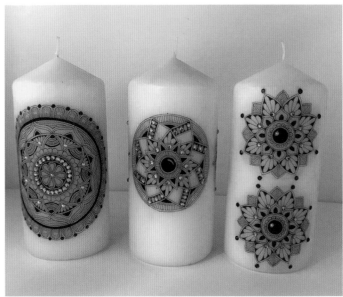

Clock

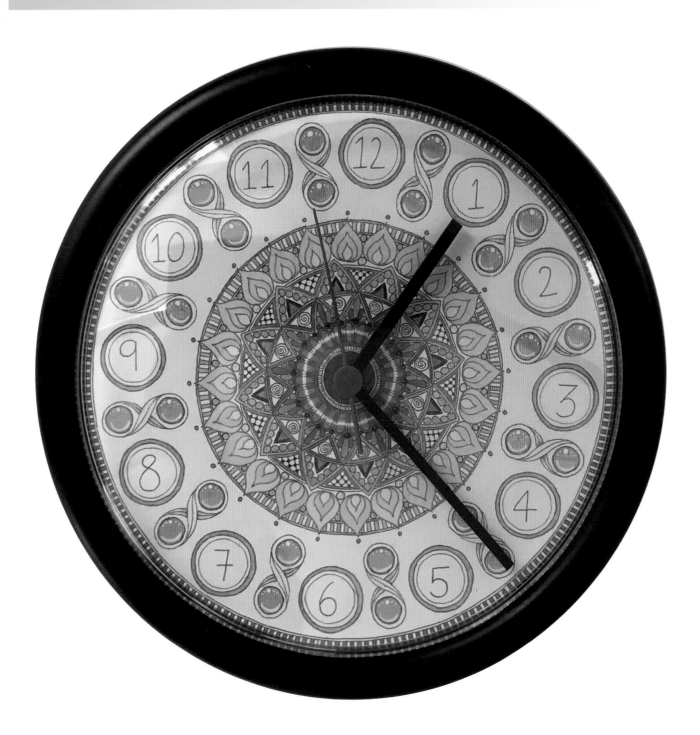

1. You can use any plastic clock kit for this project.

2. Take a piece of white 300 gsm white card stock and cut a circle to fit the inside measurements of the clock base.

3. Draw a mandala on the white card stock using the center point to position the clock mechanism

4. Carefully mark the positions of the hours from the original clock face and create your own versions to tie in with your mandala.

5. Place inside the clock and put it all together finishing with a clear plastic cover.

Jewelry

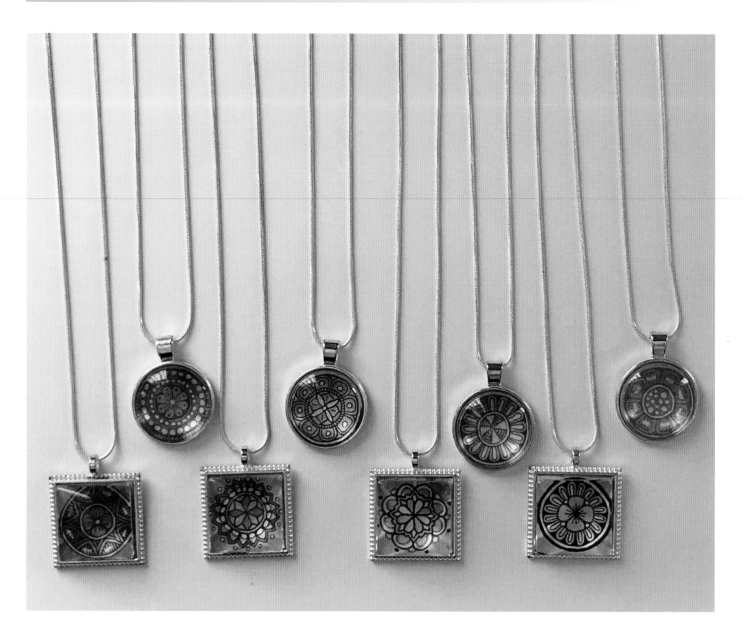

1. You can buy pendants and other jewelry in a variety of different materials, shapes and sizes. We're showing pendants here but the technique could be used to make earrings, brooches, and other items.

2. Make watercolor wash backgrounds on watercolor paper or thin card.

3. Measure and cut your colored paper to fit the silver frame.

4. Draw very small mandalas onto the cut pieces.

5. Apply glue to the back of the paper or card and stick it to the bezel at the back of the pendant.

6. Replace the flat-backed glass dome.

7. Add a silver chain.

Glass magnets

1. Three watercolor background pages were designed and then cut into circles to match the size of the glass dome.

2. Using black, orange, purple and green pens mini mandalas were drawn onto the circles

3. Mod Podge was applied to the back of each circle and adhered to the clear glass flat-backed cabochon over the top.

4. A round magnet was added to the back when dry.

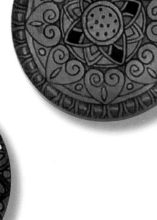

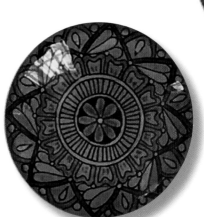

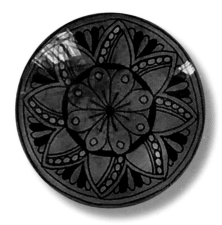

TOP TIP

Remember that you are drawing for your own pleasure so enjoy yourself and don't worry about how others might see your work. Don't worry if you make a mistake, maybe make the line thicker, color it in, add another element: dots, tear drops or very small circles are good for this or you could even choose to make it a feature of your design.

Chapter 8
Artists' gallery

While on my travels I have met lots of other like minded people who also get great pleasure from taking time out of their busy lives to draw mandalas. I invited them to take part in this book and to create some of their designs. I have included their pieces in this chapter along with the benefits they get from drawing mandalas.

Janina French

I'm a self-confessed art and craft nut living in Kent. I have painted and drawn for many years, exhibiting at annual invited shows such as Florum in Kent and The Royal Miniature Society in London. My artwork can be found on most continents in private collections. I qualified in 2016 as a Zentangle Teacher (CZT) and subsequently attending the 2017 European CZT meeting here in the UK is where I met Hannah. I was thrilled when Hannah asked me to provide a mandala for her book.

I have found the practice of drawing mandalas to be helpful in a number of ways. It provides me with a place to play, to be confident in order to take an artistic journey with no ultimate destination in mind. I use it to warm up my hand to eye co-ordination before working on a commission. I can play with color schemes, shapes, tones and even textures in a non-threatening way within the mandala framework. I use it as a form of relaxation enjoying the repetitive strokes of the pen whilst drawing the patterns. Your reward for drawing these amazing creations in the final beautiful art piece you have created. The slowing of time, the calming of mind, lowering of blood pressure and sense of wonder in your achievement. It's a great thing to do, you will love it ...

Janina French CZT #24 Kent and Sussex, UK

frenchjanina@gmail.com

Follow your dreams

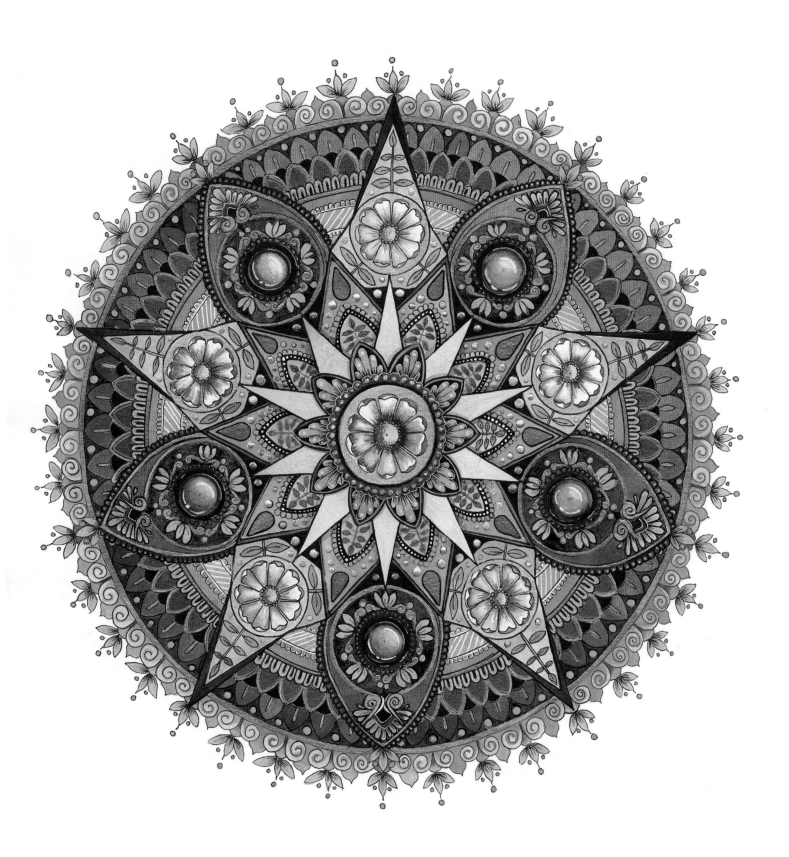

Katie Crommett

I began drawing mandalas in 2013, after taking a Zentangle and mandala class. I've been enamored with mandalas since the mid 1990s, when I was introduced to them by a friend. I drawn them on plain paper with any sort of black fine liner. Often I'll start with a compass and pencil to create a structure for the mandala. After the structure is in place, I begin in the center, using the black fine liner, and follow my intuition on the shapes and design. Rarely are my mandalas pre-planned. It's an opportunity for my intuition, imagination and love for Zentangle to play together.

Katie Crommett, CZT #15 Massachusetts USA

Katie Crommett.com

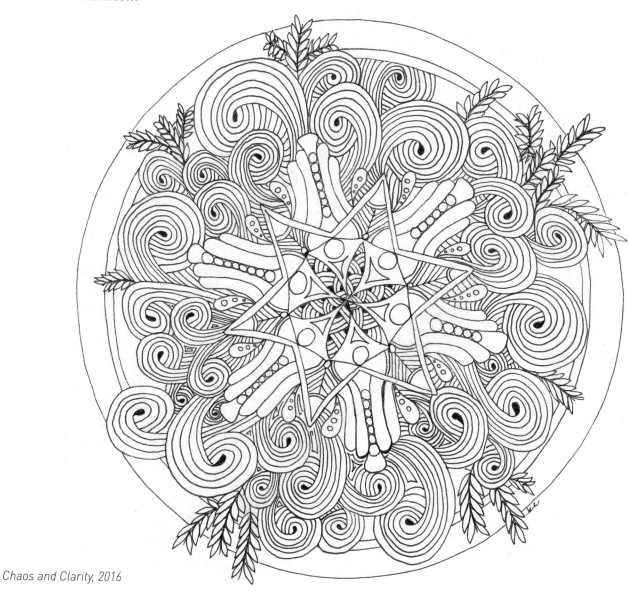

Chaos and Clarity, 2016

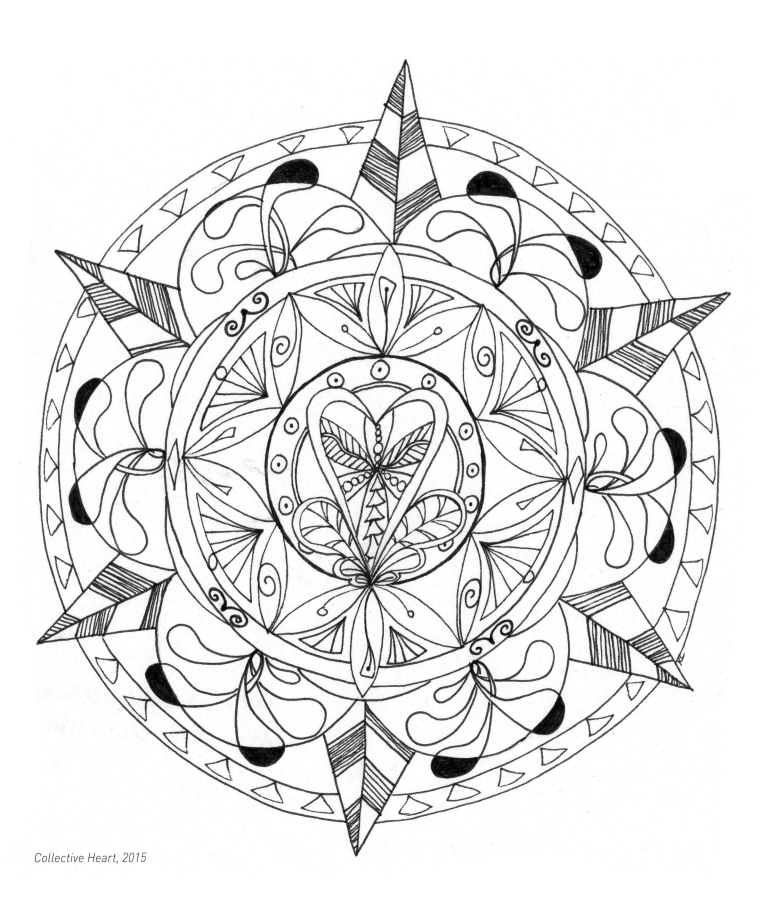

Collective Heart, 2015

Dr Lesley Roberts

For me, an important part of creating a mandala is the need to repeat the same pattern several times over, be it four, six, or eight times. This is because there is relaxation in the repetition of the simple strokes you have created. You know exactly what you are going to be doing for the next few minutes. It is a very simple way to relax, allowing yourself to focus on the ink coming out of your pen, or on the pencil marks you make with your pencil as you color it in.

Lesley Roberts CZT #9

Lesley@theartsoflife.co.uk

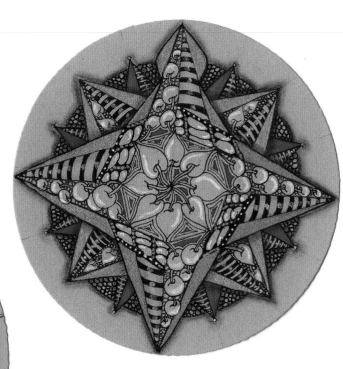

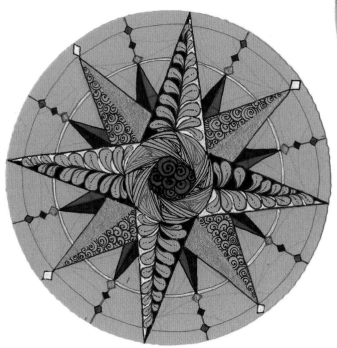

Tan

I made these two mandalas on Zentangle tiles – using a Helix Angle and Circle Maker to make the marks for the outline shapes. The patterns were then created using a range of Sakura Pigma Micron 01 pens: black, sepia, brown, red; the highlights with a white and Sakura Gelly Roll pen, and shading with a HB graphite pencil. Some areas are infilled with gold Sakura Gelly Roll pen. These mandalas are similar to compass roses, pointing at the compass directions, and were created mindfully, slowly building up one pattern at a time to complete the circular forms.

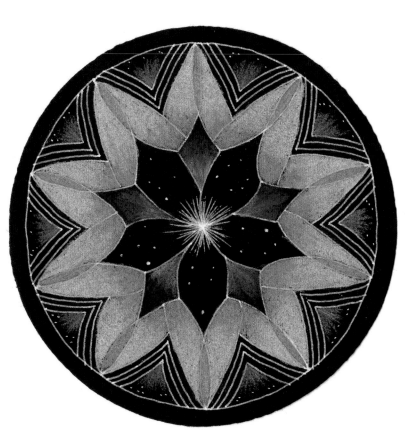

Black

These two mandalas were created on Zentangle black Zendalas. The colors were created with Prismacolor pencils, layering them up many times in some cases to achieve a range of shades and tones from each pencil. The white lines were drawn with white Sakura Gelly Roll pen.

Creating these was very mindful and relaxing, using limited colors and very simple strokes with the white pen. These mandalas feel more dramatic and playful than the tan-colored ones.

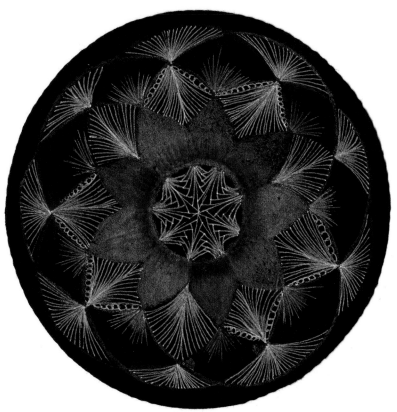

Jane Marbaix

Dreamcatcher mandala

I've been a certified Zentangle teacher since 2011. I used two-part A4 stencils to create this mandala which makes the process very easy. I love dreamcatchers so I decided to turn the mandala into a dreamcatcher. I enjoy doing these round creations as it is so relaxing, while adding color creates another dimension.

Jane Marbaix CZT #6
Author

janemarbaix@me.com

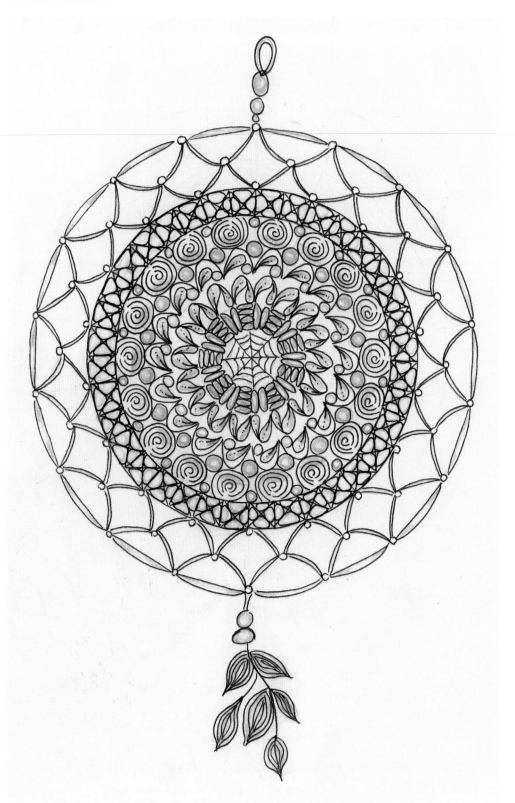

Hannah Geddes

I *love* creating mandalas, designing them, exploring, layering new patterns, and turning them into pieces that I can use on cards or gifts for family and friends. I get an immense amount of joy from being able to take a blank piece of paper and draw something beautiful that I can frame and hang in my studio.

I enjoy experimenting with new mediums and materials, drawing or painting mandalas on all sorts of substrates and decorating hand made envelopes, candles and creating dot mandalas on wooden coasters, rocks, and shells.

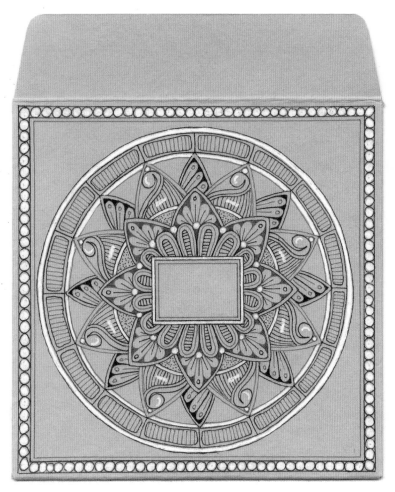

Why I draw

I draw mandalas for several reasons: when my life becomes hectic or I feel overwhelmed I will sit down, breathe and escape for a while, allowing my mind to wander as I'm drawing the repetitive strokes on the page making me feel fresh and reinvigorated. When I'm faced with difficult or important decisions and my mind is congested I will create a mandala to help unblock and free up my thoughts to focus on my inner wants and needs so I can reach the best decision.

Drawing mandalas also helps when I have trouble sleeping or can't switch off when it's time for bed. I keep a notepad and pen by my bedside and will often draw when I go to bed or if I wake up during the night and within 20 or 30 minutes I feel calmer and able to switch off and sleep.

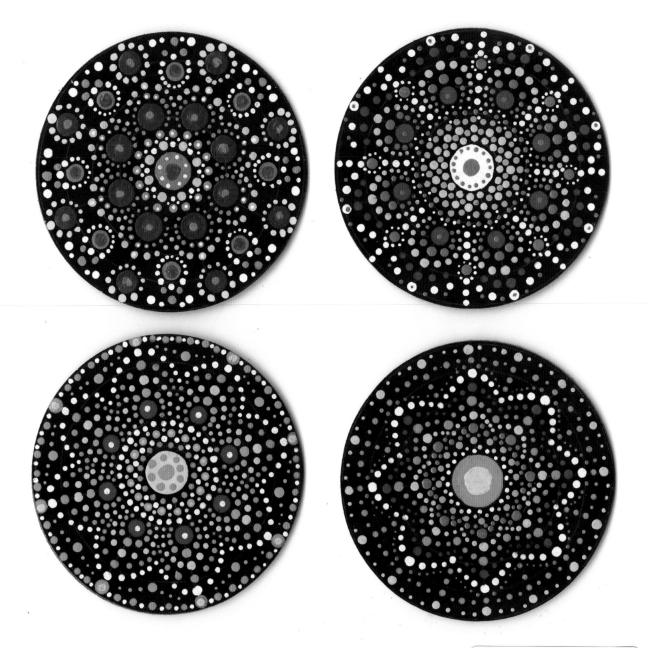

My influences

I'm influenced by a variety of styles found in other cultures, artists, nature and architecture and like to find new patterns to deconstruct then reconstruct and make varieties of new pattern designs. I always carry a notebook and pen with me and will often stop and draw the patterns I see. I once stopped and asked a lady if I could take a photo of her dress while holidaying in Malta. After I explained my interest in mandalas she brought down two dresses the following day to show me the different mandala designs so I could I photograph them and add them to my collection.

I like to combine black and white in my pieces and will often draw several mandalas of the same design. I change and vary the placement of the thick and thin lines, blocks of solid black, shading, and where I leave the negative space. Sometimes I will draw a base grid with 24 segments but as I reach the outer edges I might decide to add more pencil lines to create more segments. This allows me to draw smaller patterns in the outer concentric circles. I like playing with the outer bands and borders to see how minor changes in sizes of patterns can change the overall look of the design. I include other symbols in my designs such as the hamsa hand, yin and yang and dreamcatchers.

Teaching mandalas

I teach both adults and children how to create mandalas. Students comes to the sessions with different expectations and it's lovely to see how they relax and can switch off from everything. Their surprise that they have made such a beautiful piece of art with very simple instruction never ceases to amaze me and gives me great pleasure.

Hannah Geddes CZT #15 Herts and Essex, UK. Author
hlgeddes30@gmail.com

www.tangledwebcreations.com

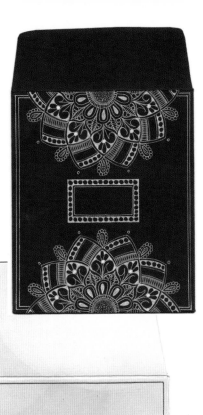

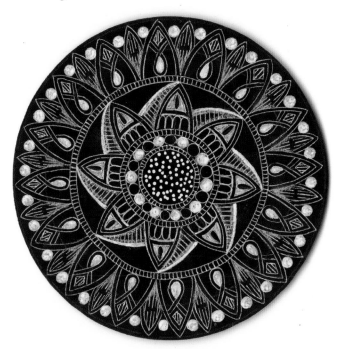

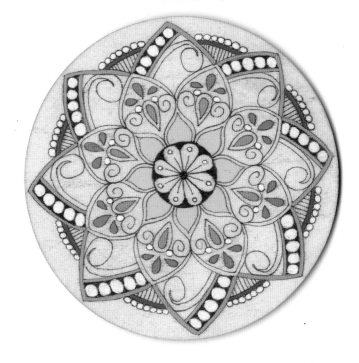

Chapter 9
Templates

Here are a series of templates to help you get started. The first two are just a basic substructure; the rest relate to the designs shown in the Chapter 5 Pattern library and the color charts in Chapter 6 Balance and harmony. Please free to copy them and add your own patterns.

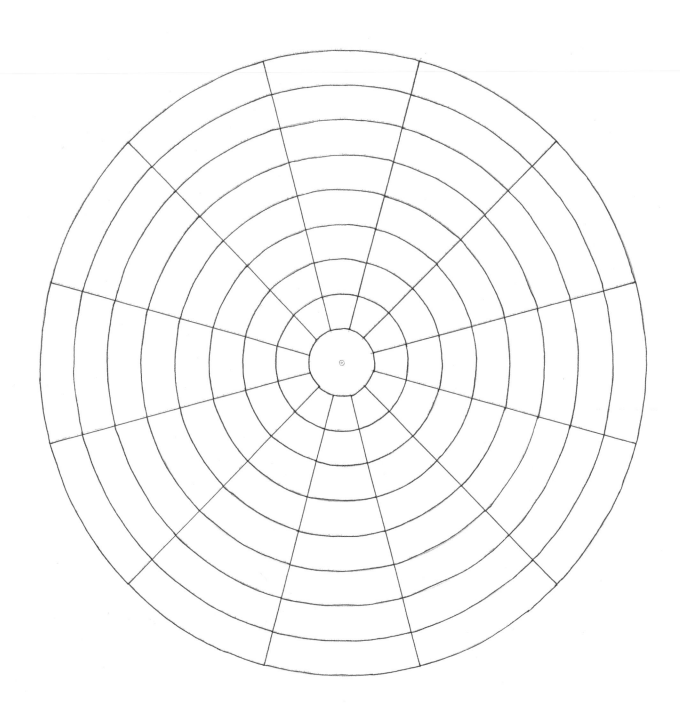

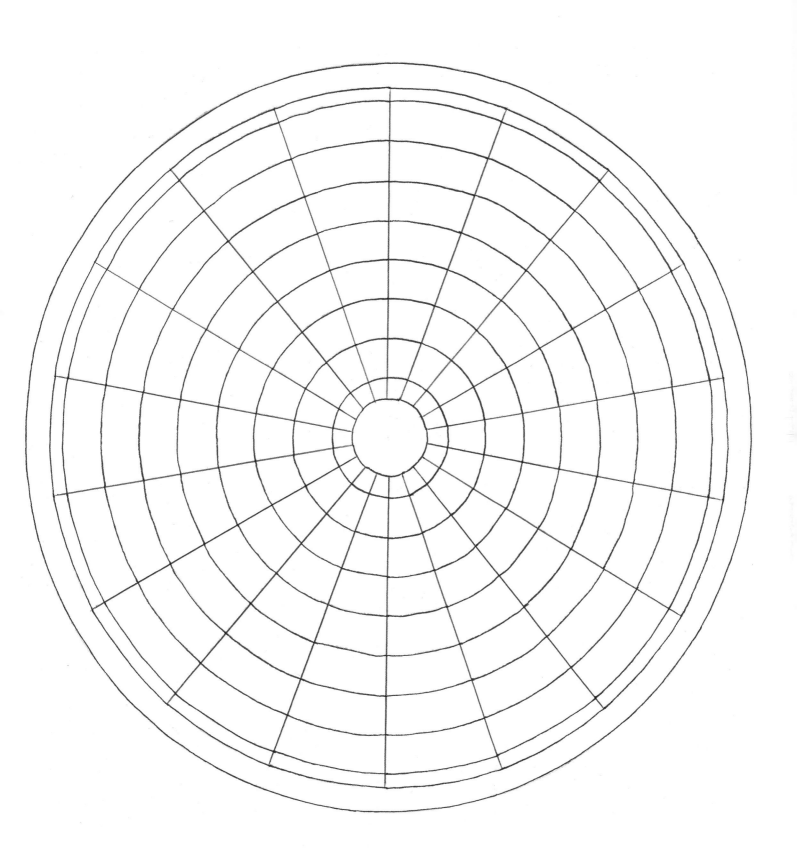

Template for creating color combinations

Template for creating color schemes

Inspiration

Isolated hues

Color balance schemes

Tints and tones

Inspiration

Isolated hues

Color balance schemes

Tints and tones

Resources

All of the below are products that I have tried and tested

1. Sakura fine liners, Gelly Roll and koi brush pen **sakauraofamerica.com**

2. Stencils **tangledwebcreations.com**

3. Card, mechanical pencil and Calli create dual tip pens **hobbycraft.co.uk**

4. Prismacolor pencils **prismacolor.com**

5. Lyra Rembrandt polycolor pencils **fila.it**

6. Helix circle 360 maker, circle and ellipse stencils **mapedhelix.co.uk**

7. Isomars Pro circle 360 protractor **isomars.com**

8. Tombow Mono eraser **tombow.com**

9. Card and other substrates **clairefontaine.eu/en**

10. Paper, card and other substrates **craftuk.net**